APR 1 3 2015

KAS

W9-BUR-630

Bibliothèque publique de la Municipalité de la Nation
Succursale LIMOGES Branch
Nation Municipality Public Library

Pissarro.

Phidal

"Perhaps we all descended from Pissarro." Paul Cézanne

"Perhaps we all descended from Pissarro." Cézanne's unequivocal comment on the artist who has been defined as the Impressionist "painter of the earth" clearly says it all. While being totally committed, but at the same time maintaining his own special, calm way of seeing things, Camille Pissarro spent his whole career telling the story of the fields, the land under the plough, the countryside, and the animals, and man — with his burdens and his work — the sleepy village and the bustling city. Camille Pissarro was able to use their games, their vibrations and their infinitely unexpected variations of light, to pay tribute to universal harmony — almost to the point of celebrating it. However, over and above the purely chronological interpretation of the epithet "Doyen of the Impressionists", which is commonly used in talking of Pissarro, there is a more precise and clearcut significance. The title obviously needs to be seen in terms of the themes, the "Impressionist" style, and all the other highly diverse factors common to painters (open air painting, studies of the landscape and the light) as appropriate. But Pissarro's particular role, one on which there is unanimous agreement, extends well beyond the mechanical, formal, or purely chronological.

Pissarro was clearly older than all the other members of the group. Born on 10 July 1830 in the French colony of Saint Thomas in the West Indies, he was two years older than Manet, nine years older than Cézanne, and ten years older than Monet, Renoir, and Sisley. Gauguin and Van Gogh were eighteen and twenty-three years his junior respectively.

The title, "Doyen of the Impressionists", devolved onto Pissarro as a result of his completely unshakeable faith, as he, therefore, took on the essentially revolutionary role for Impressionism, from both the formal and the moral points of view. For Pissarro, Impressionism represented a new civilization that needed to be researched and created with a spirit of enquiry, patience, and determination — marrying the ideals of the Late Romantics with the Realism of Corot, the school of Courbet, the research of Cézanne and Manet — so as to lead to the results achieved by Gauguin and the Neo-impressionists, to which Pissarro had a connection through his son Lucien.

He embraced the Divisionism of Paul Signac and Georges Seurat with the same enthusiasm. Thanks to his inexhaustible and unbounded confidence in the result of common research, his enthusiasm in the face of the indifference of the faint-hearted, the critics, and the detractors, he became the point of reference and the most devoted and influential guardian of the spirit that bound all these artists. He struggled to prevent splits within the group, and overcame the ob-

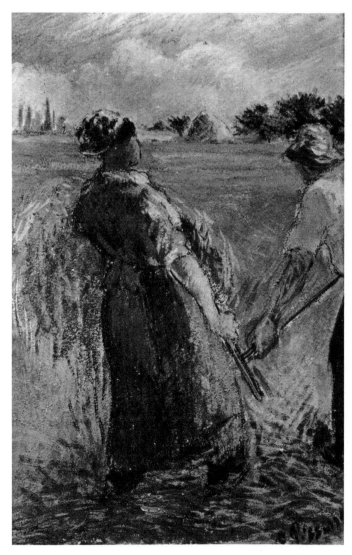

Gathering Hay, c. 1890. Private collection, USA

stacles that they all had to face and which were particularly dramatic, especially in his own case. His confidence and enthusiasm never faltered, and this was confirmed by something he wrote as an old man: "I have suffered indescribably ... what I am going through now is dreadful ... but I feel that, if I had to start all over again, I would do exactly the same things again." This perhaps explains why Cézanne wrote "the humble and great Pissarro was like a father to me. He was a man to turn to for anything, like God."

As we know, Pissarro was originally born from the Caribbean island of Saint Thomas. The heroic simplicity that Zola — the not un-disputed but nonetheless authoritative father of Naturalism — saw in Pissarro's transparent and accessible paintings was undoubtedly in-nate and the result of Pissarro's very direct contact with the earth of his native land, where the presence of nature was certainly more evident and less restrained and where such a relationship was more authentic, intimate and real. In fact, the painter experienced the reality of nature as a deep and familiar emotional link, an instinctive feeling of balance and harmony with the universe which came about through ethics rather than aesthetics: in other words, a moral rather than a formal relationship.

The young Pissarro clearly missed the luxuriant and abundant vegeta-tion of his home. Having been sent to France at the age of eleven to complete his education, he attended the Collège de Passy near Paris. He was often seen sketching coconut trees, banana groves, or horsemen wearing strange Bolivar-style hats during grammar or arithmetic lessons. When he finished school at the age of seventeen, he returned to Saint Thomas where his father, who ran a large general store in the port town of Charlotte-Amalie, immediately found him a job as a clerk. Here too, whenever he could take a break from the frantic work of recording incoming and outgoing goods, Pissarro snatched every moment and any scrap of paper he could lay his hands on and, with a sure and confident touch, he sketched the everyday scenes that his curious and ever-vigilant eye saw. He portrayed life in the port, the faces and the gestures of the port workers against the background into which they merged and which was brought to life by their presence. As he wrote later on, "in 1852 I was a well-paid clerk in Saint Thomas, but I could stand it no longer. Without a second thought, I threw in the towel and headed for Caracas."

This outcome must have seemed quite inevitable, and Pissarro's father, who had always stood in the way of his son's artistic aspirations, did nothing to stop him this time. In fact, later, he helped him get to France and even provided him a modest allowance. Camille's long-cherished dream of becoming a painter now seemed to becoming true. The young Pissarro arrived in Paris just in time to see the Exposition Universelle (World Fair) of 1855, which had a whole section dedica-ted to the figurative arts, and gave the young man from across the oceans his first chance of seeing the great names of Parisian painting. They were all there — from Delacroix and Ingres, to Corot, Dau-bigny, Jongkind, Millet, and Courbet. Everything — from colours, form, and brush strokes used by these artists who were all so different from each other — was endlessly fascinating and it is somewhat surprising that Pissarro chose Corot, the most modest and restrained among them, as his master. In the midst of their endless debates and publicity seeking stands, Corot was, in fact, the only one who conti-nued working on his own, without the support or backing of a school, thus maintaining his own distinctive style, and following criteria which fascinated his young disciples.

Pissarro was moved by the delicate touch of Corot's landscapes, and this led him to abandon his studies at the recognised art schools and take to painting in the open air, in the countryside. "You have to go out into the fields, the Muse is in the woods," said his master. And so

Pissarro discovered the evocative beauty of the French countryside, and found it satisfied his insatiable curiosity for art and forgot his homesickness for the landscapes of the West Indies. And so, "open air" painting was born.

Over and above the personal charm of the old Master and the formal evocations of his paintings, there was a clear affinity linking the two artists. Their common idiom was an intimate and deep-felt feeling for nature, which in Corot was more limpid and harmonious, while in Pissarro it was grave and austere. In both their cases, pictorial research was born of an intimate and attentive study of reality. Corot's idyllic and sentimental vein, which he inherited from Romanticism, became, in Pissarro's hands, a deep-felt and overwhelming interest in the day-to-day world. The most constant and developed theme, the moral aspect of his art, sprang from his attentive and committed gaze. This deep involvement with the human element, and the moral rigour that was as much a feature of his personality as it was of his work, brought Pissarro close to Courbet, the father of Realism, with his choice of human subjects, and his belief in art's social function.

While detached from the cultural and pictorial climate of Courbet's day, Pissarro learned his aesthetic lesson so well that his painting during that period concentrated more on volumes, thus gaining in

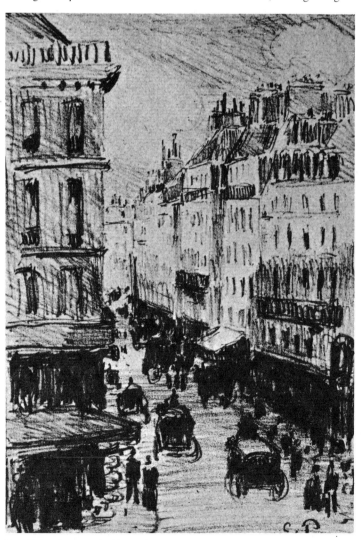

Rue Saint-Lazare, 1987. Bibliothèque Nationale, Cabinet des Estampes, Paris

4

density and power. The young painter's artistic personality was becoming increasingly individual and more original. On the eve of the 1860s, he broke away completely from the influence of the old master, dedicating himself fully to the research being undertaken by the members of what was to become the Impressionist movement.

One of his paintings was accepted at the Salon of 1859, although none was shown for the next two years. In these highly turbulent times, Pissarro had three pieces shown at the Salon des Refusés of 1863. These were years of non-stop work and relative tranquillity (he married in 1861, and his first son, Lucien was born two years later). In both 1864 and 1865, a number of his paintings were accepted by the Salon and received critical acclaim. It was during this period that Pissarro met and joined forces with the future Impressionists. Between 1864 and 1866, in the dynamic atmosphere of the Café Guerbois, he kept in close contact with Claude Monet, his old classmate at the Académie Suisse, as well as Renoir, Sisley, and Bazille, and some time later, Manet. During this period these artists established the common aims they were going to pursue, while of course maintaining their own cultural baggage and sensibility.

In 1866, Pissarro and his family moved to Pontoise, a village in the Vexin region, where he was able to indulge his love of open air painting to his heart's content. He could see his goal ever more clearly and strove relentlessly to achieve it.

"[He shows] an overwhelming concern for the truth and for justice, a harsh and powerful single-mindedness ... The artist's only concern is the truth, and consciousness ... He is neither a poet nor a philosopher, just a creator of earth and sky ... where one can hear the deep echoes of the earth, and trace the powerful vitality of the trees," Emile Zola reported on Pissarro's works exhibited at the 1866 Salon. He was particularly struck by *The Banks of the River Marne in Wintertime*, a spare, austere, essential, but undeniably powerful and deeply humane, canvas.

A number of other paintings produced that same year bear witness to the artist's highly intuitive interpretation of the views, hills, and meadows around the ancient capital of the Vexin region. Pontoise, its countryside, and its inhabitants were the recurring themes in Pissarro's work of this period. By this time, he had taken to using a palette knife which gave him scope for applying colour in wide areas. The deep tones that he was still applying in thick, heavy layers reinforced the power of the volumes, giving a feeling of monumentality to the image, hitherto absent from his work. This harsh and unyielding quality did nothing to boost sales. "Compared to the carefully prepared canvases of his contemporaries, Pissarro's look horribly bare," said Zola. These were tough years, rife with difficulties and disappointments.

In 1869, Pissarro and family moved to Louveciennes, but this time he was forced to ask for help from his friends. He remained just as single-minded as he had always been about his research, however, and between 1869 and 1870, his painting seemed to become a little softer. Using a brush, he was able to obtain a brighter, lighter effect without losing any of the realist strength.

He was utterly convinced that "the Impressionists are on the right track, this is a wholesome art, based on sensations, and it is honest ...". He restated this conviction many years later and it helped him daily to recreate this humble and immediate reality in which he believed with an almost rustic devotion. This faith made it possible for him to overcome difficulties, face adversity, and avoid losing sight of his goal.

The Franco-Prussian War of 1870 and 1871 brought even more depressing times for Pissarro in its wake.

Almost immediately after war broke out, he moved his family to England where they stayed with his mother in Surrey. He wrote to his friend Théodore Duret, an enlightened critic, and his devoted enthusiast and benefactor during his darkest days, "I have achieved nothing in terms of business or sales ... my paintings just aren't catching on here, and this seems to be my fate everywhere."

While Pissarro's stay in England was marked by bitterness and difficulties, there was an equal amount of positive development. His first contact with a different kind of landscape had an enormous impact on his evolution as a painter. The explosions of colour that obliterated the form, which he first saw in the paintings of Constable and Turner, taught him "to see the light". After 1870, the colours in his paintings became lighter and more vibrant, and were shot through with a new luminosity. The dense bitumen shadows of his earlier landscapes gave way to light and transparent veils. He gradually abandoned the Sienna shades and deep greens for analysing the shadows and the changing effects provoked by the light. However, in contrast to the majority of the Impressionists in general, and to his friend Claude Monet in particular, or even Renoir and Sisley, Pissarro was to retain a limpid and clearcut compositional style, and would continue always to give the volumes a clear and precise structure. Over and above the new influences or the return to older ideas, it is in this aspect of his paintings that his calm and meditative nature and his limpid and direct vision of reality can be seen.

He returned from England in 1871 and, after another year spent at Louveciennes, Pissarro moved back to Pontoise in April 1872 where he resumed his close collaboration with Cézanne. The Val d'Oise region no longer held any secrets for him. He knew every hilltop, every piece of scrubland, and path, and from then on, through years of progress and renewal, he explored their luminosity, the movement of the tones, and the way the shadows performed.

These years were filled with enthusiasm and confidence, and the first signs of critical acclaim gradually made themselves known. Positive criticisms became less rare, and this positive trend on the part of the official critics led to the first sales. Paul Durand-Ruel, the dealer and gallery-owner, was Pissarro's main client, as well as his old friend Duret, who had been one of the first to appreciate his talents when he had first met him in London during the war years. After Pissarro's return to France, Duret kept in touch and kept on encouraging him. But, even though some enlightened souls might have given the impression of understanding their paintings, the revolutionary innovations put forward by this small group of artists was inevitably going to be challenged, and would provoke reaction if not outrage. And this is precisely what happened when Durand-Ruel, a perceptive, if imprudent man, showed a series of Manet's paintings at his gallery in the Rue Laffitte.

Manet had been working for several years in the open air at Argenteuil with Monet, Renoir, Sisley, as well as having contacts with the Groupe de Pontoise, which consisted of Pissarro and Cézanne. Both critics and public were taken aback by the way Manet juxtaposed light and shade, and eliminated *chiaroscuro* completely in the *Déjeuner sur l'Herbe* and *Olympia*, and they were almost unanimous in crying shame. The cautious interest this new style of painting was attracting was suddenly eclipsed after this first contact with ideas that were not, in fact, that avant garde or disconcerting.

The flow of visitors to the gallery in Rue Laffitte dried up, along with the potential buyers — who had been few and far between in any event. The group did not give up, however. Adversity seemed to galvanise their spirit of solidarity and boosted their numbers. Degas and Berthe Morisot joined first, followed by Braquemonde, De Nittis and Guillaumin. With great pride and determination, they proclaimed their independence from the traditional ties and the hollow conformism of the academists. They organised their own collective

exhibitions and, despite the painful and dramatic vicissitudes he was living through, it was once again Pissarro who encouraged and supported his friends with his unshakeable faith, enthusiasm, and his total commitment to the group. Financial difficulties had brought Pissarro and his family close to total destitution, and in 1874 they had to face the heartbreak of losing their only daughter, Jeanne-Rachelle, who had inspired two portraits, a rarity in Pissarro's genre – which were absolutely first-class examples of tenderness and affection.

1874 was also the year of the disastrous exhibition by the "rebels" in the atelier of the photographer Nadar, in the Boulevard des Capucines — an exhibition conceived and organised by Pissarro. It was here that, amongst the stream of insults and derision in the press, Louis Leroy, writing for *Charivari*, coined the term *"impressionniste"*, taking his cue from a painting of Monet's entitled *Impression: Sunrise*. Intended as a term of abuse, it was then adopted by the targets themselves who wanted to highlight their own artistic individuality. They even went so far as to name the magazine, that Pissarro and his colleagues established three years later, *Impressionniste*. This publication became the vehicle for expounding and spreading the word about their theories and their art.

For a number of years, the hostility of the critics and the public had a major influence on the economic well-being of these artists as well as having the effect of condemning them to a professional no-man's land. Then, as is often the case, the few friends who had kept the faith, and the enlightened souls, whose number had imperceptibly increased, came to understand the innovative value of their work. They were able to persuade successfully the true enthusiasts, in the first instance, and the general public later, of the incontrovertible value of this concept which was often misunderstood because it was so advanced. But, while a faint light could be seen at the end of the tunnel for Impressionism, the last to benefit was Pissarro himself. The humble subjects he chose, and the unadorned and sincere rusticity of his themes made his paintings less than inviting and difficult to sell. Zola had said of him: "You ought to know that you do not please anyone and that your painting is too bare and black ... A grave, austere painting, an infinite respect for truth and justice ... you, Sir, are a big clumsy fellow — and you are an artist I like!" Some years later he was to add, "The artist's only concern is for the truth, the conscience ... He stands before a natural view and sets himself the task of interpreting the horizons as they are, without attempting to modify anything ... you can hear the deep voices of the earth, and feel the powerful life-force of the trees ..."

Over time, Pissarro's painting had become less austere and less serious, richer in light and tonal nuances, but the sincerity of his interpretation and narrative, as well as his search for the truth remained unchanged and were still just as baffling to the observer. He had to wait until the first half of the 1880s before his message was understood, and before he could benefit from the modest, but nonetheless, noticeable advantages offered by this change of fortune.

The first encouraging results boosted his enthusiasm and recharged his creative energy. While some of the original exponents moved away from the movement for personal reasons, Pissarro, who had linked his entire life to the fortunes of Impressionism, kept the faith through thick and thin. He was in fact the only one to take part in all eight of the Impressionists' exhibitions, right through the last, held in 1886, and he struggled to keep the group together.

Having overcome the problems that had forced them to leave their home in Pontoise three years earlier, the Pissarro family moved back in 1882. The area, which had been rediscovered and sketched many times over with an ever-fresh eye, regained its attraction for Pissarro. The acclaim and the consequent sales that resulted from the Exposition des Indépendants, held in the Rue Saint Honoré in March 1882, had been a confidence booster and seemed to augur well for the future. Unfortunately, the financial reverses suffered by Durand Ruel, the great patron of Impressionism, ensured that there was still some way to go. Pissarro was undaunted, and his creative energy continued to produce ideas, themes, and experiments. He moved around a fair amount, often going abroad in his search for new locations. He discovered Rouen with its old streets, its beautiful monuments, and the busy port life.

His thirst for new ideas, his total commitment, and his objective vision of reality attracted him to the recent work of his friend, Seurat, and, even more so to the young Paul Signac, author of *De Delacroix au Néo-impressionnisme*. His faith in the laws of science, and in the possibility of rendering nature objectively, had led him to believe in the idea of establishing a direct relationship between art and science, which would give an aesthetic, as well as moral, value to this new approach to painting. His ideas were based on the work done by Chevreul, Maxwell, and Rood on the decomposition of light, which were particularly topical in the second half of the 1880s.

During this period, Divisionism must have seemed to Pissarro like the key to the fulfilment of the Impressionist principles, and the key to overcoming the vagueness which had been seen as a major limiting factor, and the key to the emphasis of the limpidity and the conciseness of his own pictorial idiom. With mathematical rigour, Pissarro analysed colours into their constituent parts by decomposing them systematically. But, while his paintings of this period are transformed in their "construction" by the unconditional use of this process, and achieve the rigour of geometric abstractionism, Pissarro was never able to eliminate his personal intervention and emotional involvement from his landscapes and figures. The vibrations of the light, the variations of tones in the atmosphere betray his personal involvement, and distance him from the formal analysis of his Divisionist friends for whom landscapes often became mere research tools, whereas for Pissarro, they were always a source of emotion.

The honesty and moral coherence that had always guided his painting led him to abandon the "Pointillist" ideal in about 1890, and return to the artistic *credo* that was closest to his vision — the world of nature, the land and its fruits, and man and his relationship with the earth. It was not an easy decision to make, but the intense activity of these years helped him to overcome the crisis.

Pissarro had been having trouble with his eyes for some time and, after a while, he was forced to abandon the humid Pontoise climate and move to Eragny-Bazincourt, where he was to spend the rest of his life, travelling occasionally. Public and commercial acclaim brought success for Pissarro in its wake, and this was confirmed by his first personal show held in 1892. Between 1891 and 1900, he travelled extensively, visiting London, Belgium and the Netherlands, Rouen (a city he already knew) and made frequent trips to Paris, returning each time with new ideas and emotions to transpose into his painting.

In the latter part of his life he was more frequently forced to contemplate and paint his landscapes and urban views from behind the shelter of windows to protect him from the cold, the damp and the wind — which had become the major enemies of one of the first, and undoubtedly one of the greatest, exponents of "open air" painting. Despite these limitations, he continued to cast his gaze upon the world, man, and nature with an unerring and touching enthusiasm. His last paintings sometimes even seem to be suffused with new and more vibrant tones, and he seems to discover the power of certain colours.

When Pissarro died, on 13 November 1903, the French countryside and its villages, and the streets of Paris and their inhabitants, lost their poet, and the world became aware that it had lost "a truly great master who had left his personal mark on the painting of the day."

1. View of Pontoise, Quai du Pothuis - 1868. Kunsthalle, Mannheim - *Pissarro was influenced by Corot during this period, and this is reflected in this painting. However, the landscape reflects Pissarro's direct emotional involvement — which differs considerably from Corot's romantic approach — with greater modulations and contrasts in Pissarro's approach to the portrayal of light.*

2. Sente de la Justice at Pontoise - 1869-79. Private collection, USA - *We are still some way from a conscious link with the Impressionist movement, but the preliminary elements are already clearly visible. There is, in fact, nothing solemn or allusive in this painting. The landscape is caught in a particular moment in its day-to-day existence — one of Pissarro's favourite themes.*

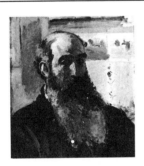

3. Self-Portrait - 1873. Musée d'Orsay, Paris - *This was the first of four self-portraits and shows him at the age of forty-three. His unsmiling face, painted in a range of dark colours is further emphasised by the lighter background which seems to isolate him in a kind of self-sufficiency. His long beard and his pose bring to mind a biblical figure.*

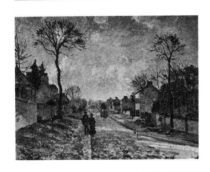

4. A Road in Louveciennes - 1872. Musée du Louvre, Paris - *This is one of the landscapes painted by the artist after the Franco-Prussian War of 1870-1871, after his return from England. He spent a long time pining for the French countryside and the Vexin area where Pissarro and most of his Impressionist friends lived for a long time. The poetic intimacy with which he explored and captured all its little views shines through in its painting.*

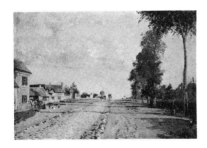

5. The Road to Rocquencourt - 1871. Private collection, USA - *In this canvas, which was painted after the artist's return from his forced exile in England, was a result of the Franco-Prussian War. We can see clear evidence of his recent discovery of English landscapes. The horizon has widened, the sky has more movement but, above all, the light is clearer and more vibrant.*

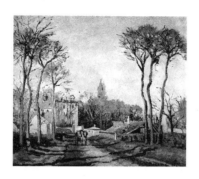

6. Entrance to the Village of Voisins - 1872. Musée d'Orsay, Paris - *Each of Pissarro's landscapes reflects his emotional involvement with the particular moment portrayed on the canvas. The deep-felt ties that bound him to a particular part of the village, a path, or the shadows of the trees, or the profiles of the houses are underscored by the immediacy with which his brush stroke brings them to life.*

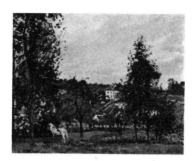

7. Landscape with White Horse in Field, l'Ermitage - 1872. Private collection, USA - *The light splash of the horse standing out against the background vegetation infuses a sense of subtle movement on the scene. The countryside was a source of constant inspiration for Pissarro. However, it was not the countryside as such that attracted him, but the life that animated it, through which the artist perceived the deep-rooted link which has always bound man and nature.*

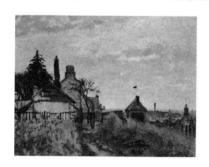

8. View of Pontoise - 1872. Musée du Louvre, Paris - *Over and above the clear-cut definition of the volumes which were a typical trait of Pissarro's painting, we can see his pictorial research. Like his friends, the future Impressionists, he wanted to capture the infinite effects created by the light and the metamorphosis of tones and colours in a vibrant atmosphere.*

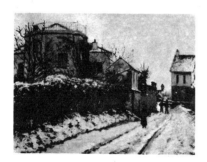

9. Street in Pontoise, Winter - 1873. Mme Florence Gould Collection, Cannes - *As painted by Pissarro, the villages of the French countryside, with their paths, ploughed fields, and modest houses, are brought to life by an unsophisticated, but authentic presence, conveying the perfect harmony that exists between man's day-to-day life and the seasonal shifts of nature.*

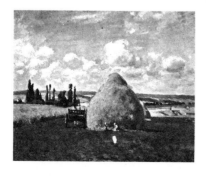

10. The Haystack, Pontoise - 1873. Private collection, France - *The artist was able to capture perfectly the reality of man working in the fields, his toil and his communion with nature. In this painting, Pissarro was able to freeze a particular moment of the life of the countryside. The tones, and the clearly defined volumes, the low and open horizon, the luminous and vibrant sky, all contributed towards communicating the serene peace of this sunlit moment.*

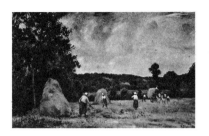

11. Gathering Hay, Montfoucault - 1876. Private collection, USA - *The change of season was a constant source of wonder to Pissarro, who sought to capture its most down-to-earth and everyday aspects. Eschewing any kind of glorification, he offers us a serene image of the peasant's summertime work. The light splashes, denoting men, and the horses give life to the scene and almost suggest the rhythms of the work, framed against a background of lush green.*

12. The Côte des Boeufs at l'Ermitage, near Pontoise - 1877. National Gallery, London - *In this painting, the setting and structure reflect the influence that Pissarro and Cézanne had on each other — which was rooted in a personal, and professional, friendship. Pissarro's great strength, however, is the calm intensity of his representation, which he achieved through a perfect fusion of subject and light.*

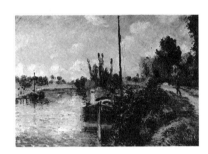

13. Banks of the Oise, Pontoise - 1877. Private collection, USA - *This painting illustrates Pissarro's artistic progress. We can see the influence of the other members of the Impressionist school, particularly Claude Monet. His strokes are more rapid, and follow the evolution of the light in the foliage, while reproducing the infinite variety of reflections on the water.*

14. Orchard in Bloom, Spring, Pontoise - 1877. Musée du Louvre, Paris - *A close look at this painting reveals the painstaking care the artist took in capturing every detail. The perfect synthesis with which Pissarro conveys the serenity of the whole scene, and his personal involvement, help us appreciate the spirit of observation that he used to achieve such representative intensity.*

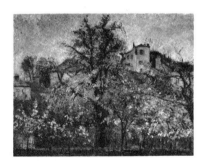

15. Sente du Chou, Pontoise - 1878. Musée Municipal, Douai - *Pissarro's painting was always marked by a clearcut and precise design, and well-defined volumes. However, he was always able to convey the impression of lightness and harmony, the rich and ever-changing atmosphere which he perceived in the surrounding countryside. The sky almost seems to be moving while a warm and diffuse light envelops the whole scene.*

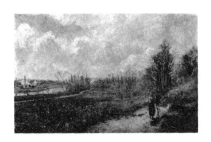

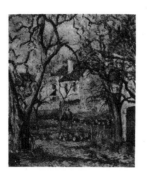

16. A Garden, Pontoise - 1878. Kojiro Matsubata Collection, Kobe - *This work belongs to the period of Pissarro's most intense and dedicated enquiry into Impressionism, an enquiry he never abandoned, even during his brief flirtation with Divisionism. In effect, he always aimed to transmit his emotional impression by eliminating any trace of intellectual or academic influence.*

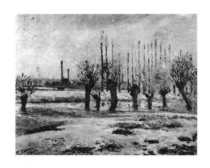

17. Effect of Snow near Pontoise - 1879. Private collection, Switzerland - *Like the other Impressionists, Pissarro loved to paint snow-covered winter scenes. Such conditions were ideal for capturing the changing effects of the light reflected by the snow, whose myriad reflections reverberated in the surrounding countryside.*

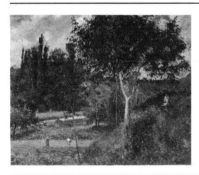

18. Fond de Saint-Antoine, Pontoise - 1879. Private collection, USA - *This painting was done during a difficult period for the Impressionists, and for Pissarro especially. In this particular year, the artist had started to detect some signs of changing attitudes on the part of public and critics, despite the opposition, hostility, and severe financial strain. The conviction and enthusiasm that shone through in his landscapes made him the most authentic and natural of the "rebels" of the art world.*

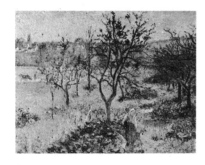

19. Gardens in Le Valhermeil - 1880. Paul Rosenberg Collection, Narodni Gallery, Prague - *This is one of the most "Impressionist" of Pissarro's paintings. His unflagging research, which aimed at transmitting the extraordinary effect that the changing light had on shadows, colours, and the forms of objects, led him to paint using short quick strokes.*

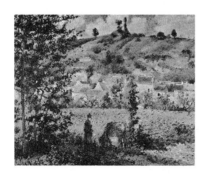

20. Chaponval, Landscape - 1889. Musée du Louvre, Paris - *This is one of Pissarro's most modern and innovative masterpieces. The perfect formal synthesis, particularly in the details of the houses, already hints at Cubism. The modulation of colours is clearly impressionist, enhanced by an unusual, highly personal, and compact approach to composition.*

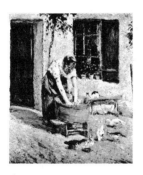

21. The Laundress - 1878. Private collection, USA - *Despite public misunderstanding, the hostility of the critics, and grave financial problems, Pissarro maintained his belief in an art form which could transmit the immediacy of the artist's emotions. In this highly detailed little painting, Pissarro synthesises the effort involved in everyday activity and perfect communion with the natural world.*

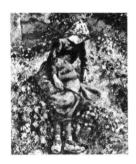

22. Peasant Girl with a Stick - 1881. Musée d'Orsay, Paris - *Like his fellow Impressionists, Pissarro almost always placed his figures against green backgrounds so as to study the effect of the light as it penetrated the foliage and reflected from it. However, the subject is never a mere pretext, and the pure poetry transmitted by this portrayal of a peasant girl confirms the artist's personal involvement.*

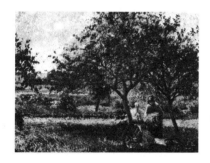

23. The Red Roofs, View of a Village in Winter - 1877. Musée d'Orsay, Paris - *This was one of the paintings that outraged the critics, who were unable to see further than the academic theories they considered inviolable. Pissarro has used his exceptional sensibility to successfully bring together all the warm tones of the greenery, the red of the roofs and the play of light and shade amongst the bare trees in the foreground.*

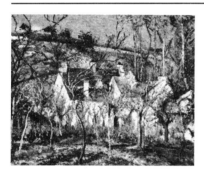

24. The Wheel Barrow - c. 1881. Musée du Louvre, Paris - *The study of the different chromatic effects caused by the changing light on foliage and on silhouettes never distracted Pissarro from the design and form of the painting, as shown in this work, where the chromatic vibration of the atmosphere does not detract from the peaceful and dignified figure of the peasant woman.*

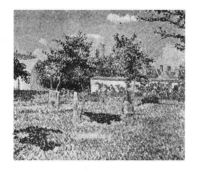

25. Woman in an Enclosure, Sunshine in an Eragny Field - 1887. Musée d'Orsay, Paris - *This painting, which dates from Pissarro's early Divisionist period, gives a clear indication of the painter's analytical and detailed research, as well as his attentive study of the systematic decomposition of tones into their constituent parts. Pissarro was, nonetheless, able to maintain his original touch, and was able to convey a more instinctive and immediate perception of reality itself in the context of this brief interlude.*

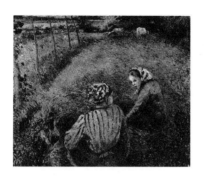

26. Girls Tending Cattle, Pontoise - 1882. Private collection, USA - *The painter has conveyed all the serene balance and harmony of the peasant women's short break, and conveys the tranquillity of the surrounding countryside. The canvas dates back to a relatively trouble-free year in the artist's life. After the Seventh Exposition des Indépendants, which opened in March 1882 in the Panorama at Reichshoffen, it looked at if Pissarro's painting was finally achieving recognition.*

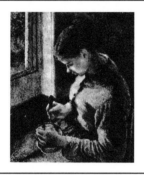

27. Breakfast - 1881. The Art Institute of Chicago - *The pure and extremely detailed interpretation of the forms, the extraordinarily rich and balanced variety of tones, and the insight with which the painter captures the intimate poetry of this moment — a simple everyday gesture — make this one of Pissarro's greatest works.*

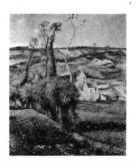

28. The Côte du Chou, Pontoise - 1882. Private collection, USA - *The clearcut and precise definition of form was an original feature of Pissarro's painting, and one which would always distinguish him from his Impressionist colleagues. Although the common subject was light and tones, and the other artists focused mainly on capturing moods, Pissarro concentrated his efforts on conveying the poetry of man's day-to-day cohabitation with nature.*

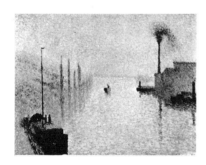

29. Île Lacroix, Rouen, Effects of Fog - 1888. John G. Johnson Collection, Philadelphia - *The influence of his friends, Signac and the young Seurat, is clearly to be seen here. This was Pissarro at the peak of his Pointillist period, when his forms were at their most elemental. The contours seem to be muted, thanks to the detailed decomposition of the colours which reach the point of suggesting a rarified and suspended atmosphere.*

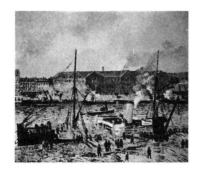

30. Unloading Wood in Rouen - 1896. Private collection, USA - *After experimenting with Divisionism, crowd scenes and the vitality of human toil fired Pissarro's enthusiasm, inspiring new works. His return to Rouen stimulated many new ideas and subjects for his compositions. These are richer and more complex, constructed on different planes, and show completely new variations of structure.*

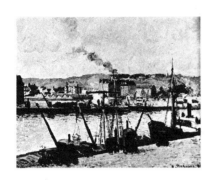

31. Morning, Rouen - 1896. Private collection, France - *This work dates from Pissarro's last period. His relative financial security allowed him to move around more easily in his search for new places and ideas. However, the recurring problem of his ailing eyesight was increasingly intruding on his life and work.*

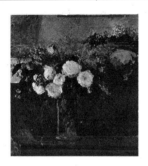

32. Roses from Nice - 1902. Private collection, USA - *This is quite an unusual theme in Pissarro's work. His love of nature was principally expressed in the more dynamic and "real-life" aspects of nature, such as the countryside, the changing seasons, work in the fields, the village with its streets and houses. Here too, the painter brings all his attention to bear on nature, which is, undoubtedly, the main feature of the painting.*

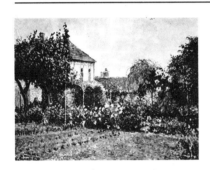

33. The Vegetable Garden at Eragny - 1897. Private collection, USA - *Apart from the various brief trips he made, Pissarro spent his last years at Eragny. The garden with its trees, flowerbeds, arbour, and orchard provided a never-ending flow of ideas and inspiration, and it was here that he created his most intense and mature works.*

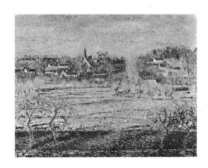

34. February, Dawn, Bazincourt - 1893. Rijksmuseum Kröller-Müller, Otterlo - *Having abandoned Pointillism completely, Pissarro had returned to a style that corresponded more closely to his sensibility and his research on nature. The play of light and the search for tonal values in this painting seem to emphasize his difficulty in breaking away from Divisionism, as he strove, in his own words, "... to get back what I had lost and yet not lose what I might have learned".*

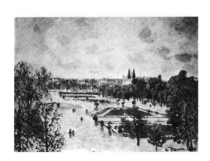

35. Jardin des Tuileries, Morning, Grey Skies - 1899. Private collection, USA - *The Parisian cityscape seemed to hold a particular attraction for Pissarro during the last years of his life. He applied himself to studying its different aspects with his usual curiosity and commitment. It was not unusual for him to capture the changes that the succession of the seasons, or even the passage of time imposed on the light and the atmosphere, and he often produced several different versions of a given view.*

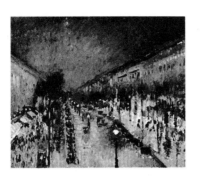

36. Boulevard Montmartre, Night Effect - 1897. National Gallery, London - *The back of the canvas bears the following in Pissarro's own hand: "Boulevard des Italiens, effet de nuit". Pissarro did not produce many nocturnal landscapes, but, particularly during his later years when he was fascinated by the city and the throbbing excitement of its streetlife, the evocative play of the night-time lighting of Paris seemed to offer an added attraction.*

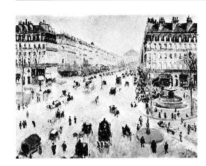

37. Place du Théâtre Français - 1898. Reims Museum - *This work, a product of the artist's last years, was one of the paintings most highly acclaimed by the critics. Pissarro painted from inside his bedroom in the Hôtel du Louvre, where he was forced to stay not only because of his eye trouble, but also to take shelter from the cold, damp, wind, and dust. The movement in the street and the light on the scene communicate the painter's affection for city life.*

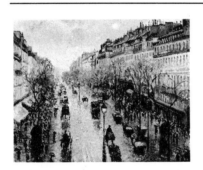

38. Boulevard Montmartre, Afternoon, Rainy Day - 1897. Private collection, USA - *An ideal source of inspiration for the paintings of his last years, the city streets, with their movement, hustle and bustle, and constantly changing colours, offered a new aspect for Pissarro to work on — the rain — which was like a glistening veil on which the artist devised a surprising range of optical modulations and vibrations.*

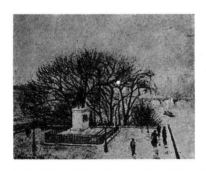

39. The Pont Neuf, Monument to Henry IV, Fog - 1901. Staechelin Collection, Basle - *The evocative quality of this corner of Paris, the calm that emanates from it, captured on the canvas like a soft intimate atmosphere, with its diffused light and its blurred tones, bring to mind the intimate harmony of some of his countryside landscapes. Pissarro's personal involvement here is just as dynamic and vibrant.*

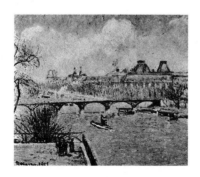

40. View of the Seine from the Pont Neuf - 1901. Staechelin Collection, Basle - *The Seine was a favourite choice of subject for the Impressionists. The myriad reflections of light on the water lent themselves admirably to their research into light. The Seine made an increasingly frequent appearance in the work of Pissarro in his later years, when his style had fully matured.*

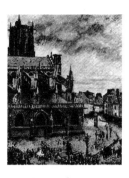

41. Church of Saint-Jacques, Rainy Day - 1901. Private collection, USA - *Although his eyes were giving him increasing trouble, Pissarro travelled extensively during the later years of his life looking for new sources of inspiration. The titles of paintings reflect the attention he paid to each composition. Each landscape was painted several times, at different times, and under different climatic conditions so as to best capture the variations in the light.*

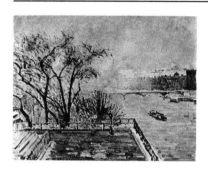

42. The Louvre under Snow - 1902. National Gallery, London - *As well as water, snow was a favourite subject for the Impressionists as it effectively becomes a screen which reflects colours, light and shadows. In this painting, which shows a view of Paris under the snow, on a snowy morning, Pissarro composed one of his "symphonies of light", the most harmonious and silent of all the works of the Impressionists.*

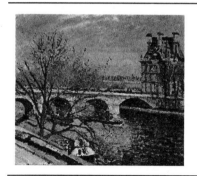

43. The Pont Royal and the Pavillon de Flore - 1903. Musée du Petit Palais, Paris - *This was one of his last works. His age and continuing eye problems seem not to have affected him at all. With his usual unflagging energy he captured this little view of Paris, and other places, which stimulated his emotions and reawakened his inspiration.*

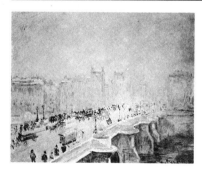

44. The Pont Neuf - 1902. Private collection, USA - *A subject that was particularly dear to Pissarro in his later years, this corner of Paris was captured at different times of year and different times of the day, at its busiest and at its quietest. His rapid, light touch, with its livelier colours, defines the silhouettes in the street and seems to beat the rhythm of the life and the bustle in the wider and more luminous background landscape.*

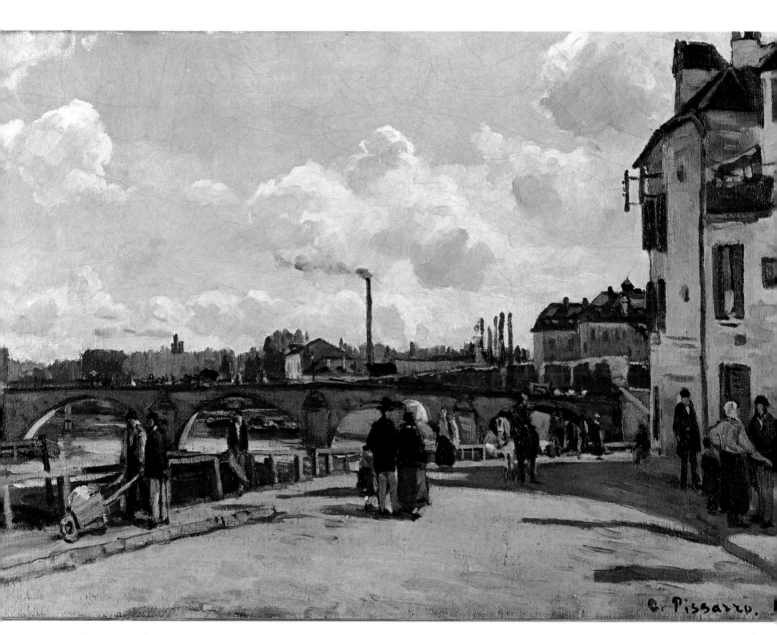

1. *View of Pontoise, Quai du Pothuis* - 1868. Kunsthalle, Mannheim

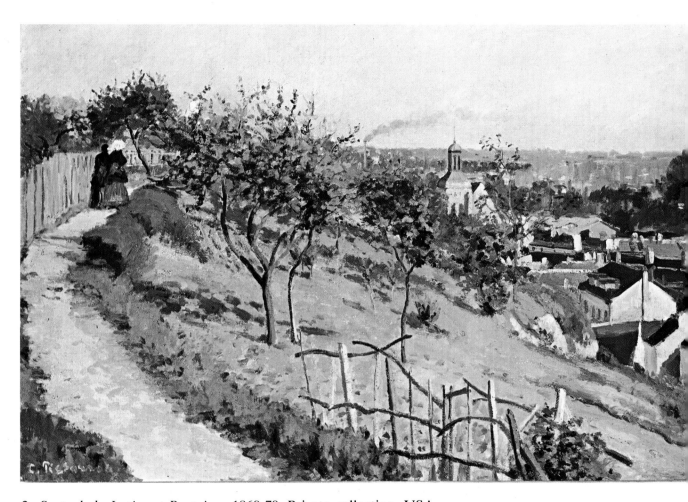

2. *Sente de la Justice at Pontoise* - 1869-79. Private collection, USA

3. *Self-Portrait* - 1873. Musée d'Orsay, Paris

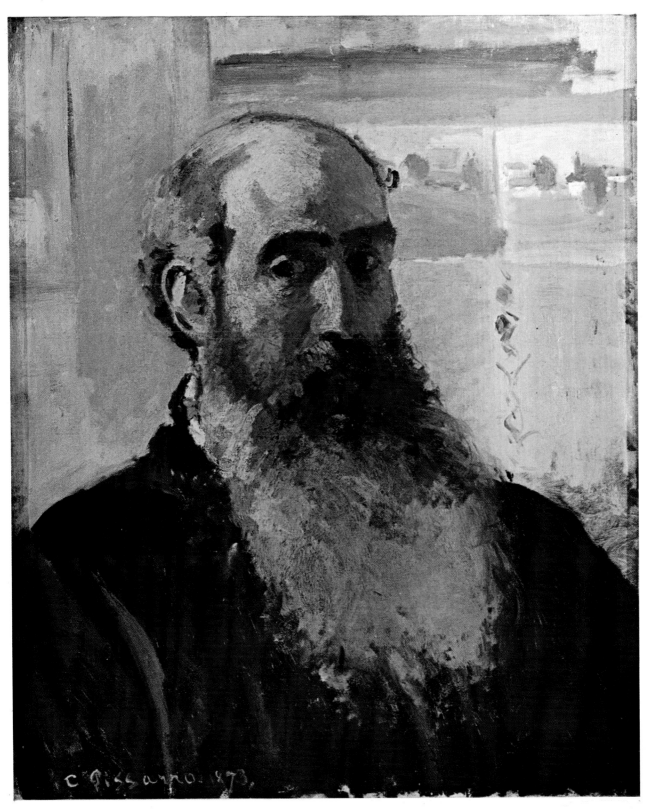

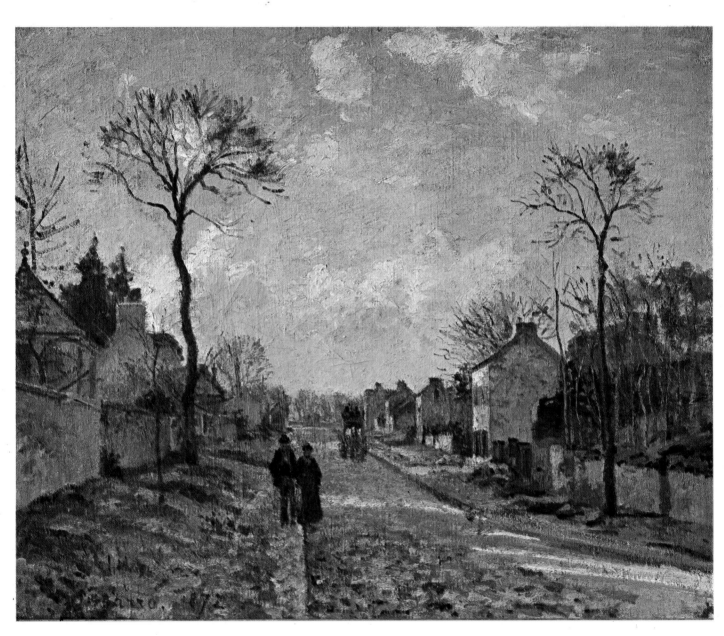

4. *A Road in Louveciennes* - 1872. Musée du Louvre, Paris

5. *The Road to Rocquencourt* - 1871. Private collection, USA

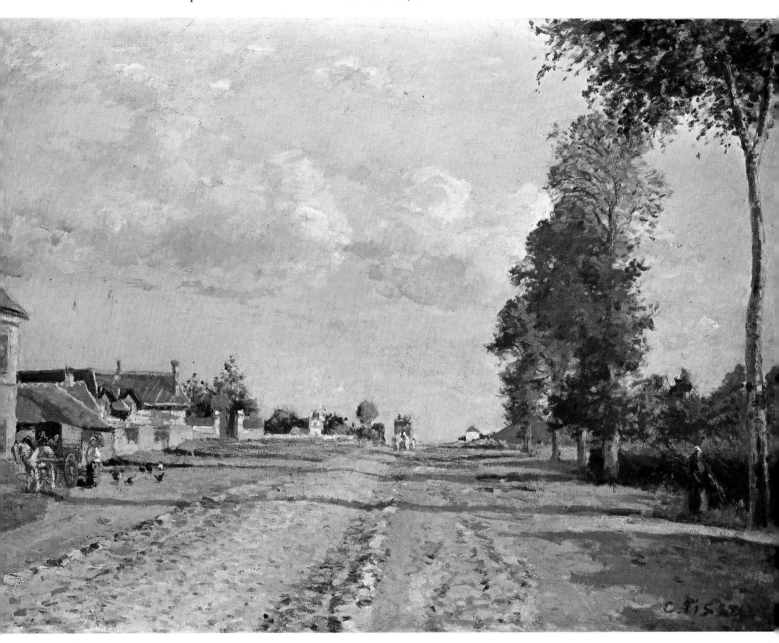

6. *Entrance to the Village of Voisins* - 1872. Musée d'Orsay, Paris

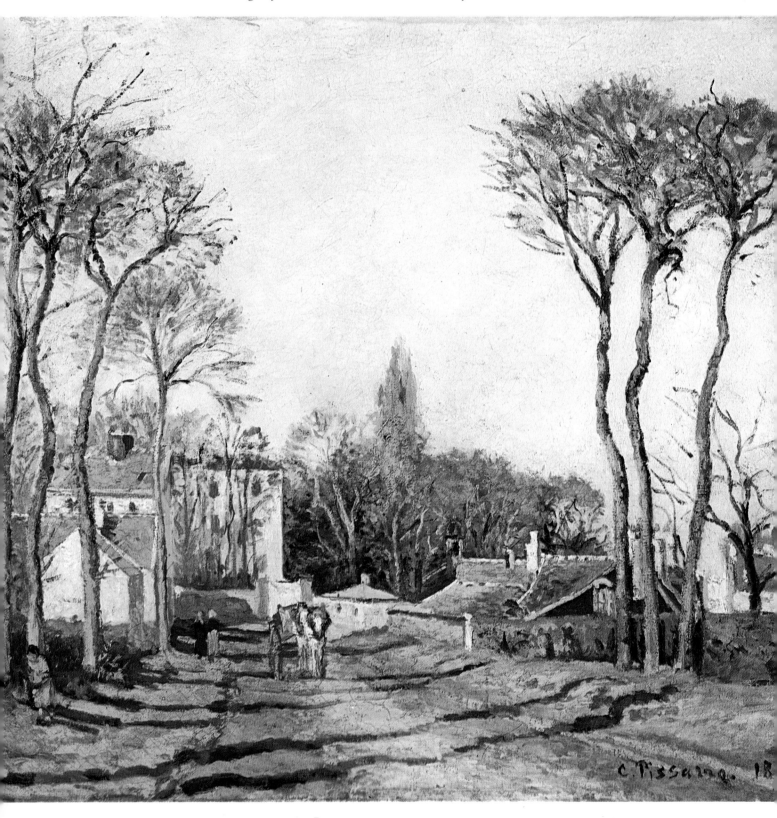

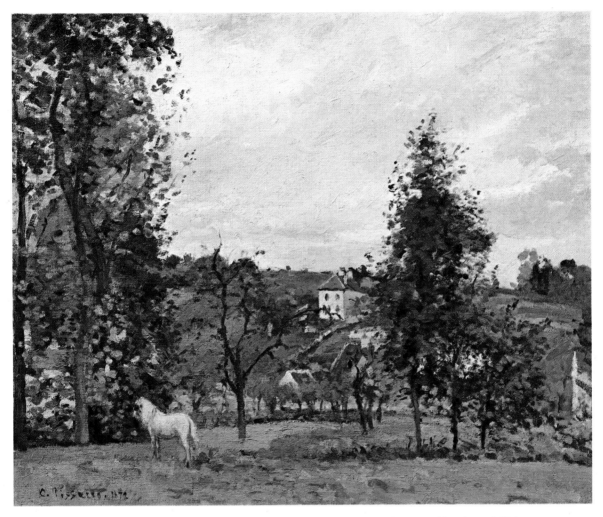

7. *Landscape with White Horse in Field, l'Ermitage* - 1872. Private collection, USA

8. *View of Pontoise* - 1872. Musée du Louvre, Paris

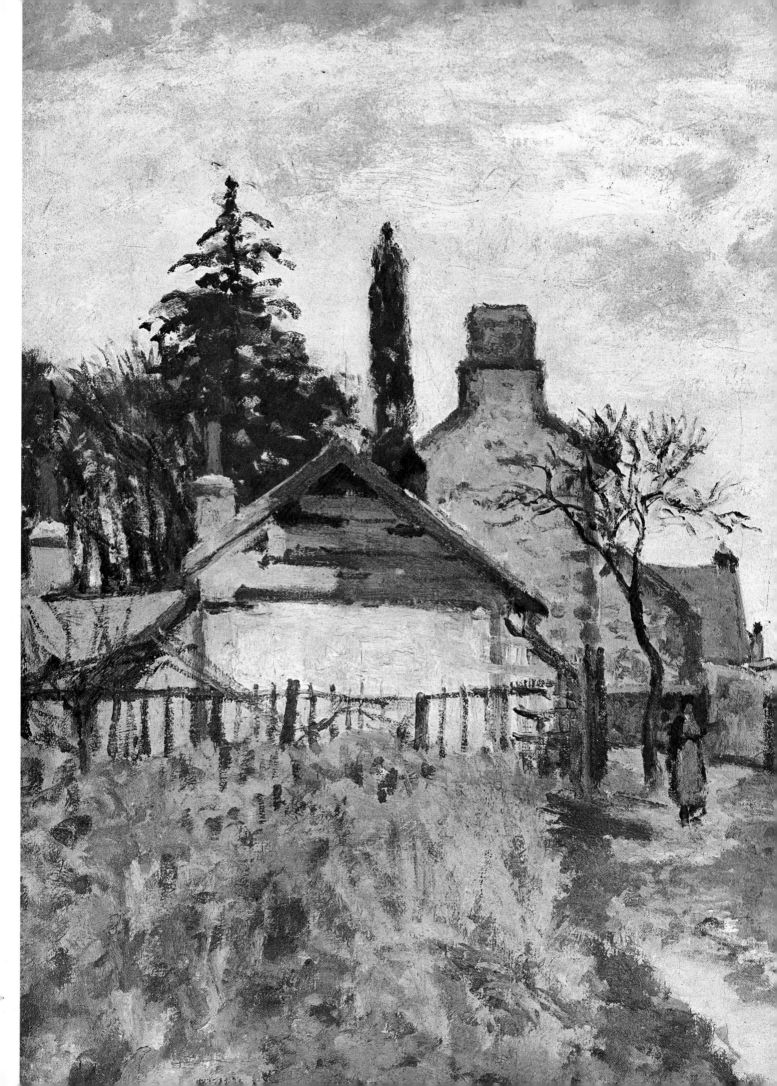

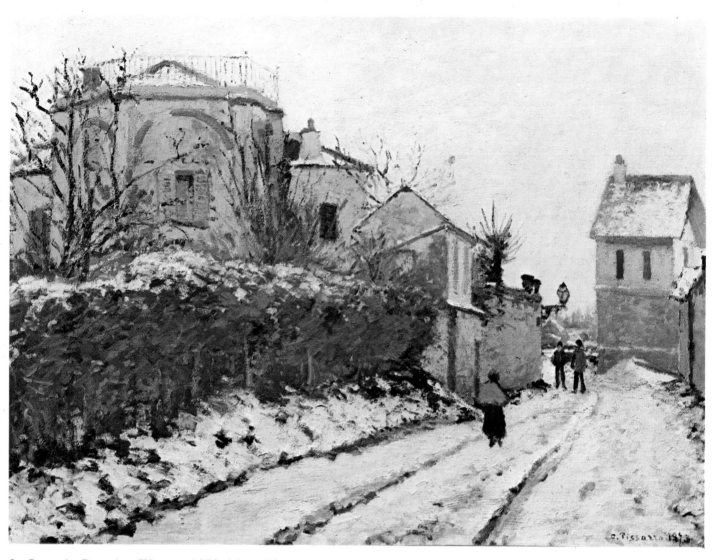

9. *Street in Pontoise, Winter* - 1873. Mme Florence Gould Collection, Cannes

10. *The Haystack, Pontoise* - 1873. Private collection, France

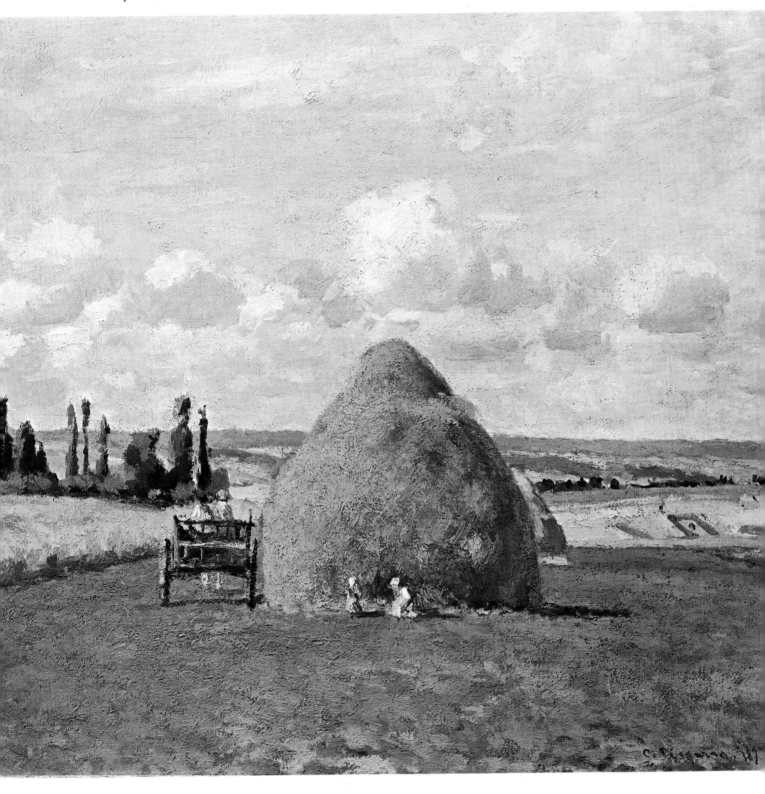

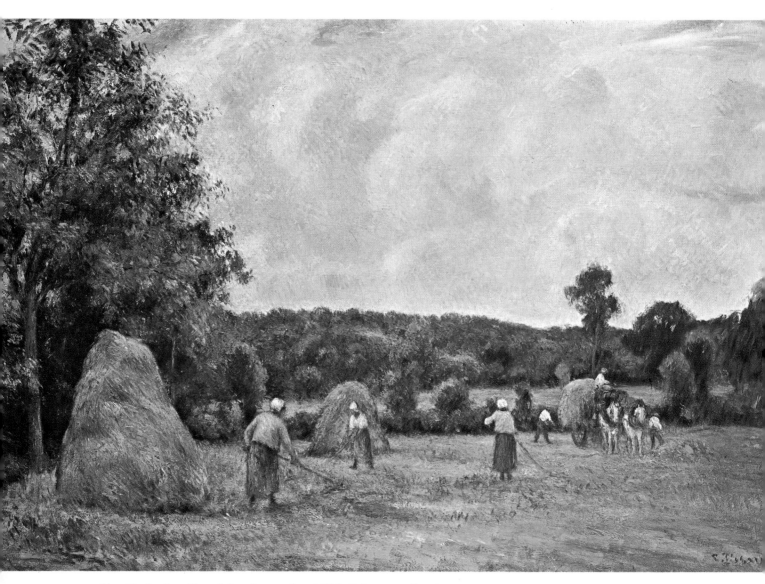

11. *Gathering Hay, Montfoucault* - 1876. Private collection, USA

12. *The Côte des Boeufs at l'Ermitage, near Pontoise* - 1877. National Gallery, London

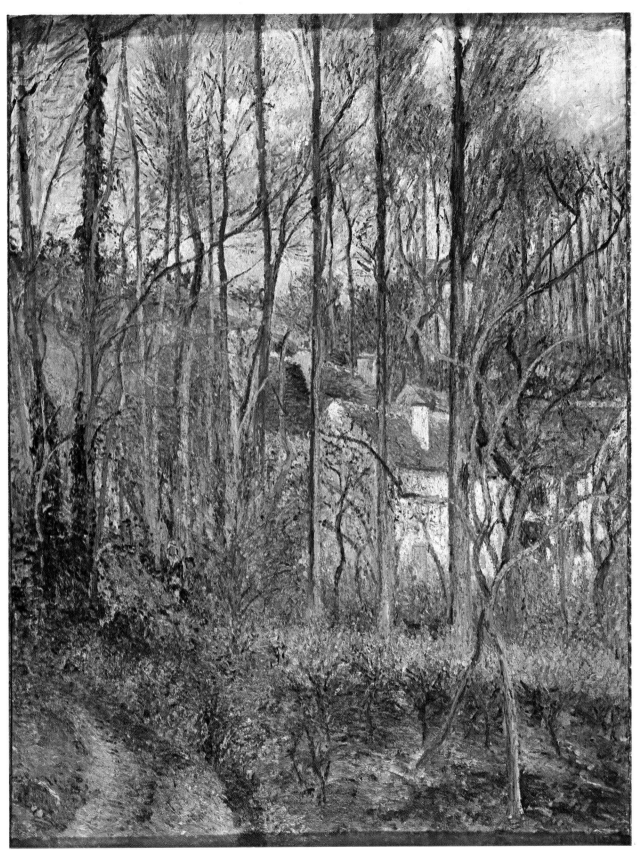

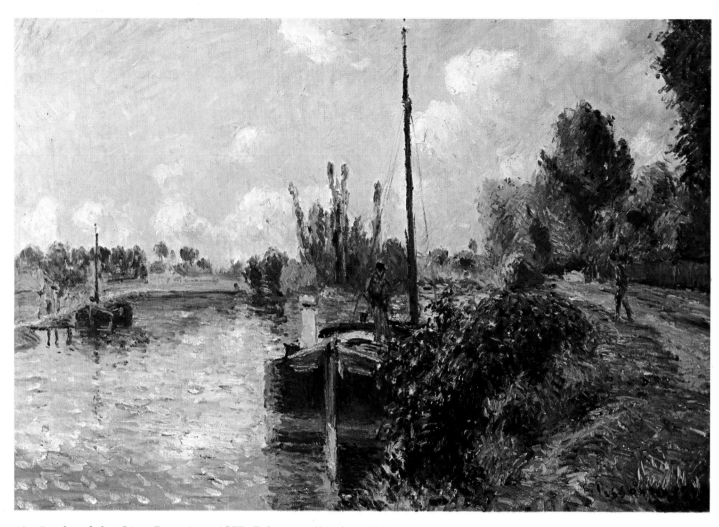

13. *Banks of the Oise, Pontoise* - 1877. Private collection, USA

14. *Orchard in Bloom, Spring, Pontoise* - 1877. Musée du Louvre, Paris

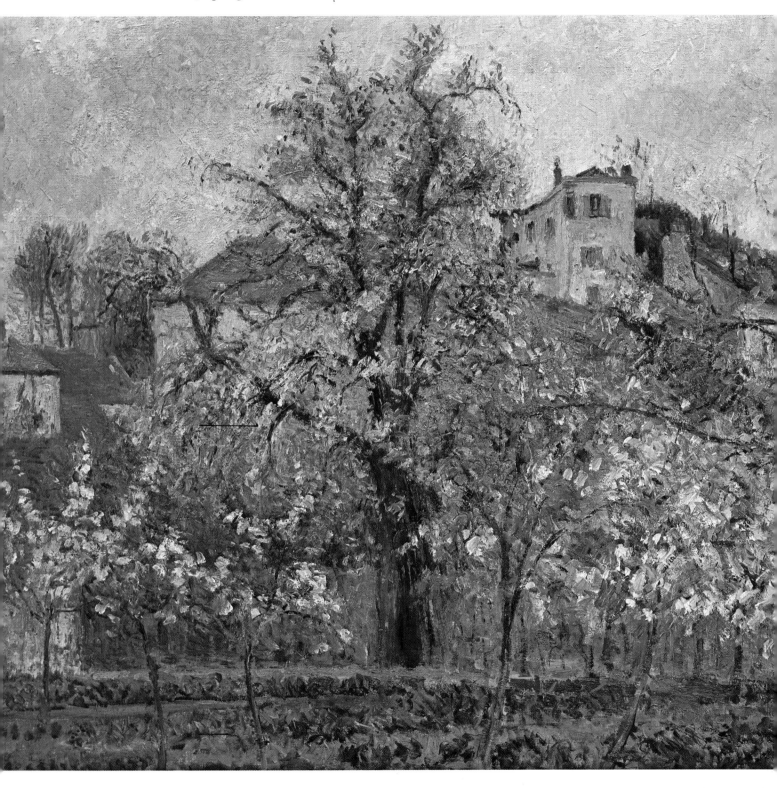

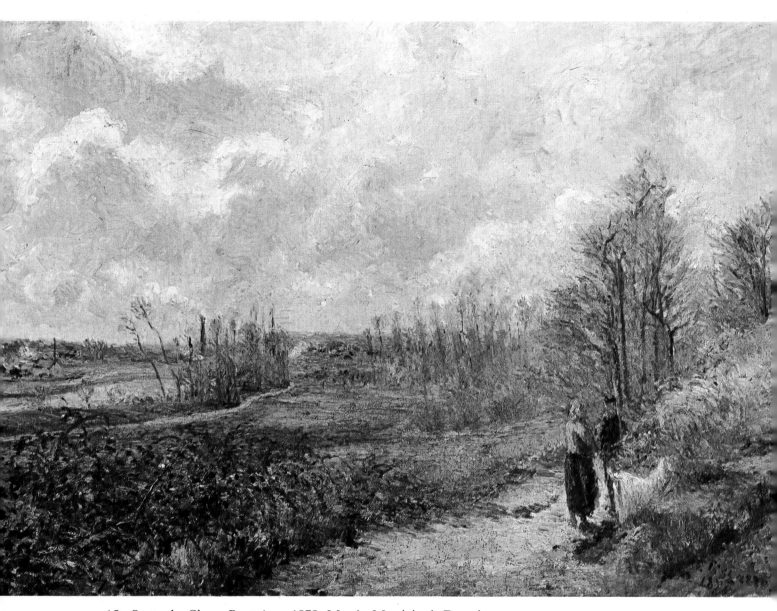

15. *Sente du Chou, Pontoise* - 1878. Musée Municipal, Douai

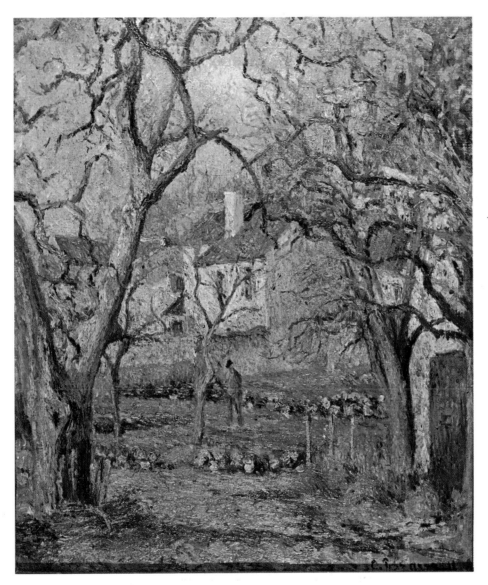

16. *A Garden, Pontoise* - 1878. Kojiro Matsubata Collection, Kobe

17. *Effect of Snow near Pontoise* - 1879. Private collection, Switzerland

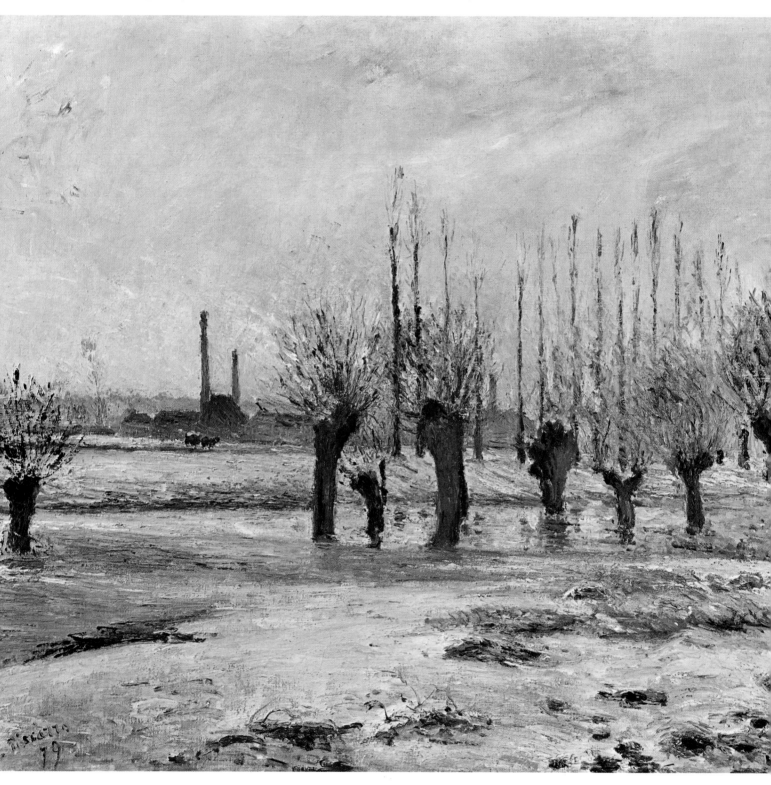

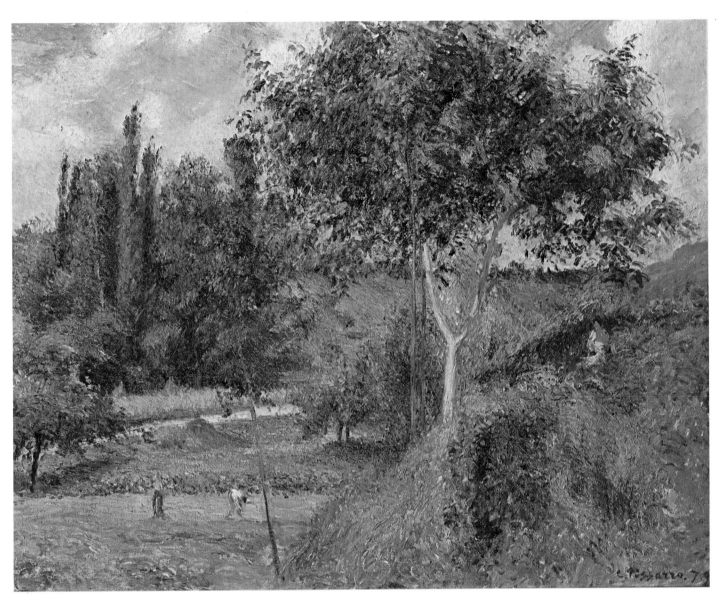

18. *Fond de Saint-Antoine, Pontoise* - 1879. Private collection, USA

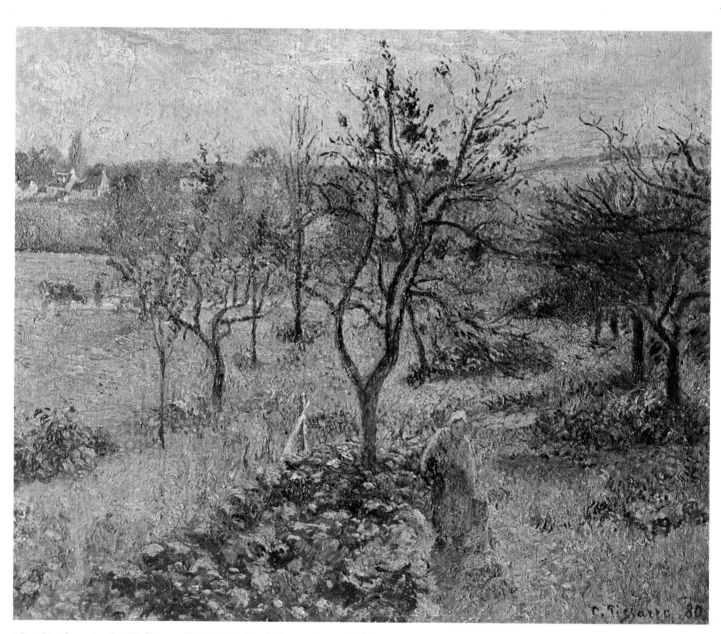

19. *Gardens in Le Valhermeil* - 1880. Paul Rosenberg Collection, Narodni Gallery, Prague

20. *Chaponval, Landscape* - 1889. Musée du Louvre, Paris

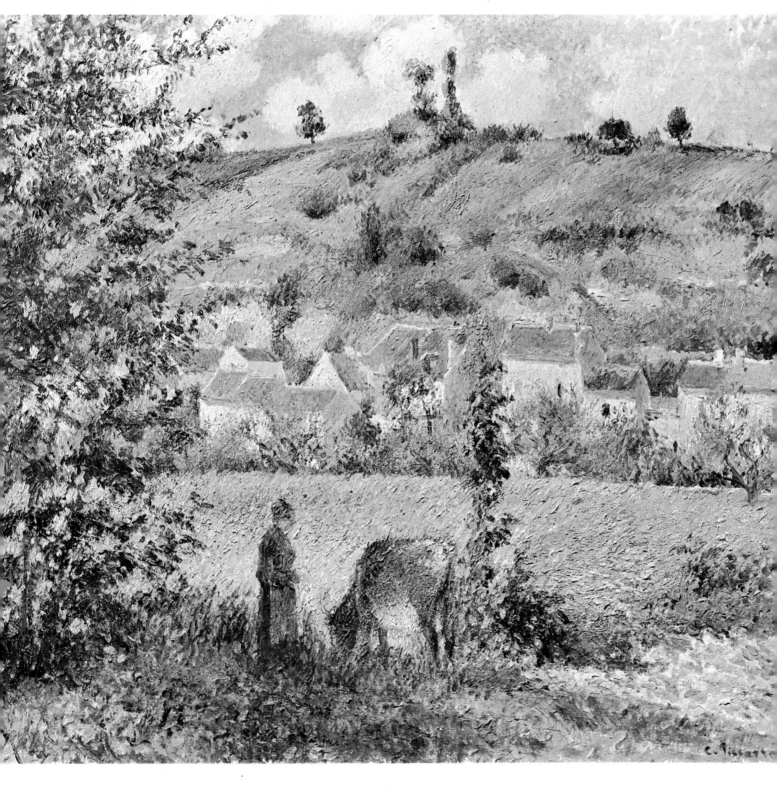

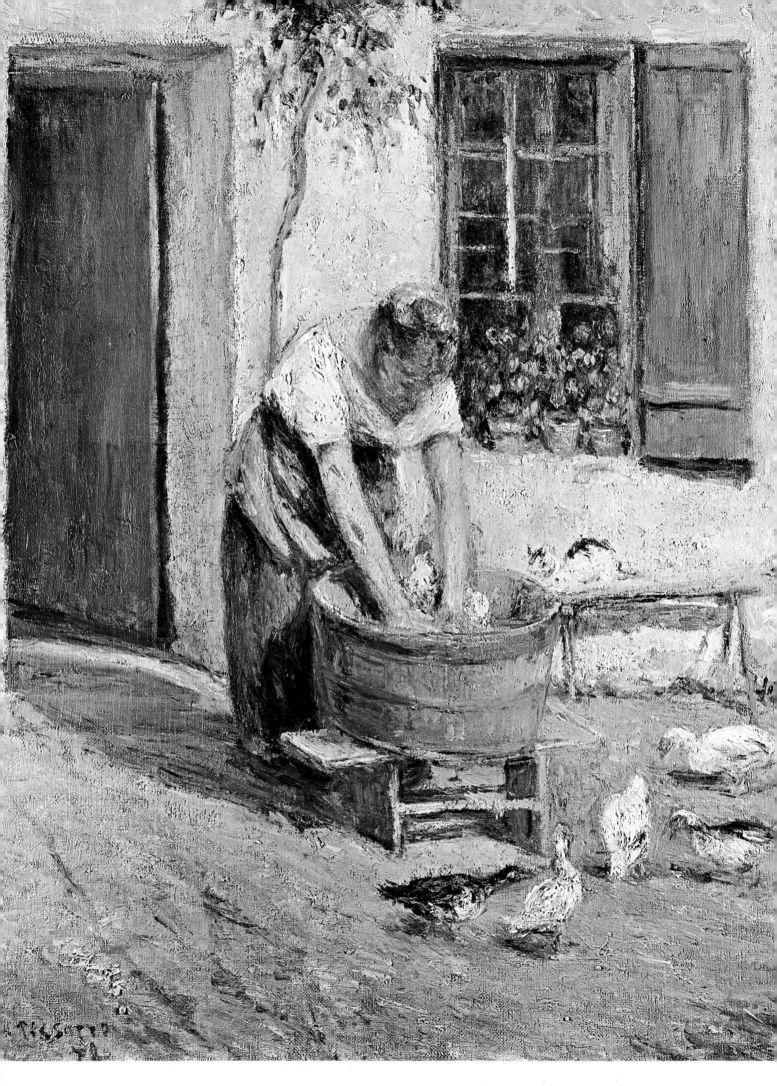

21. *The Laundress* - 1878. Private collection, USA

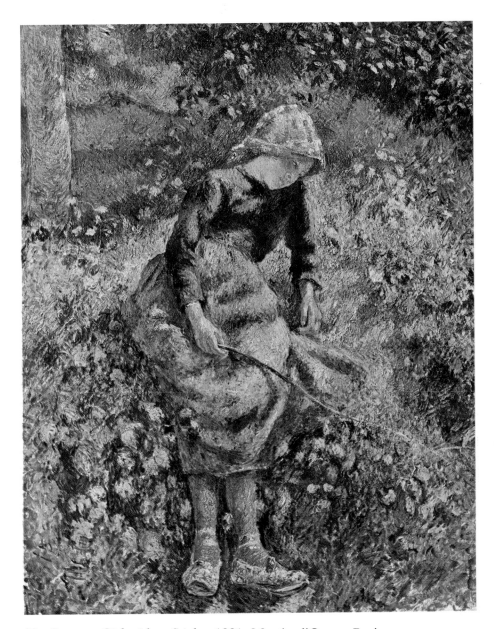

22. *Peasant Girl with a Stick* - 1881. Musée d'Orsay, Paris

23. *The Red Roofs, View of a Village in Winter* - 1877.
Musée d'Orsay, Paris

24. *The Wheel Barrow* - c. 1881. Musée du Louvre, Paris

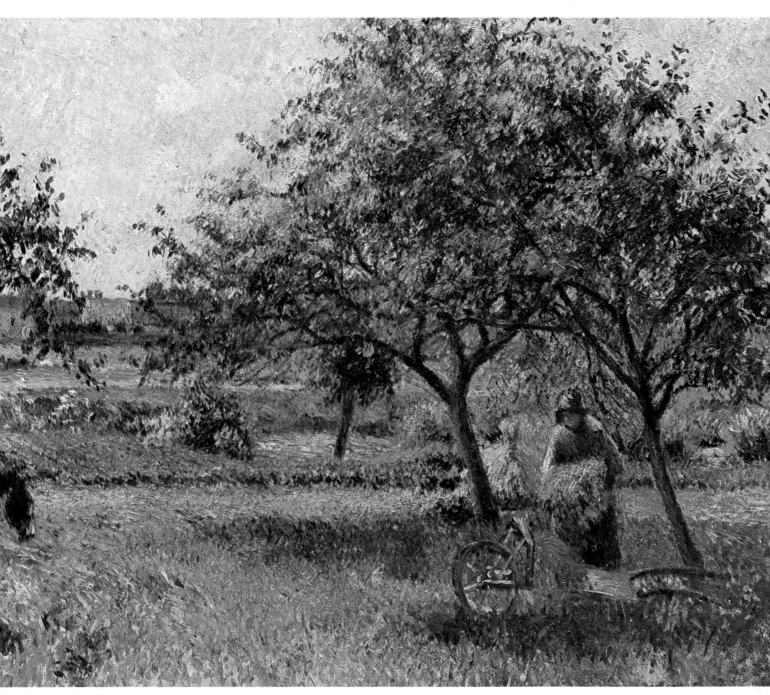

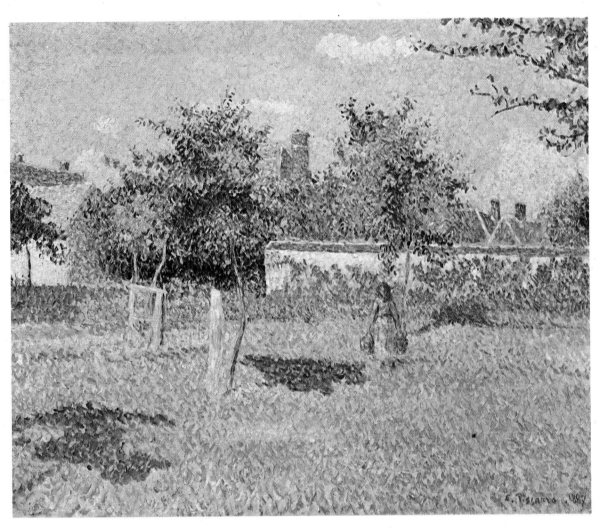

25. *Woman in an Enclosure, Sunshine in an Eragny Field* - 1887. Musée d'Orsay, Paris

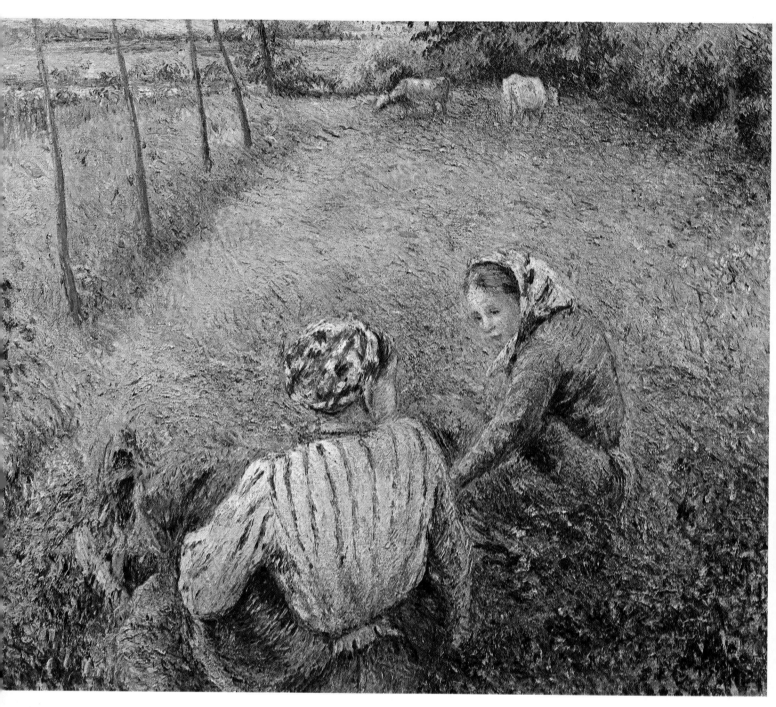

26. *Girls Tending Cattle, Pontoise* - 1882. Private collection, USA

27. *Breakfast* - 1881. The Art Institute of Chicago

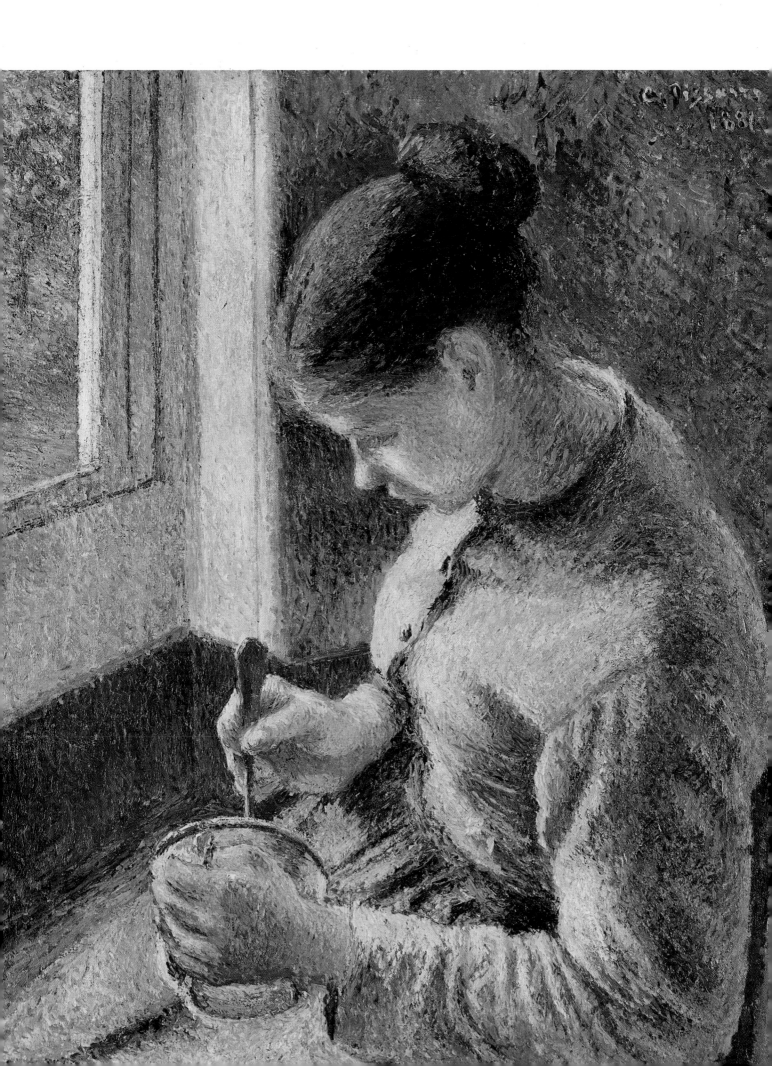

28. *The Côte du Chou, Pontoise* - 1882. Private collection, USA

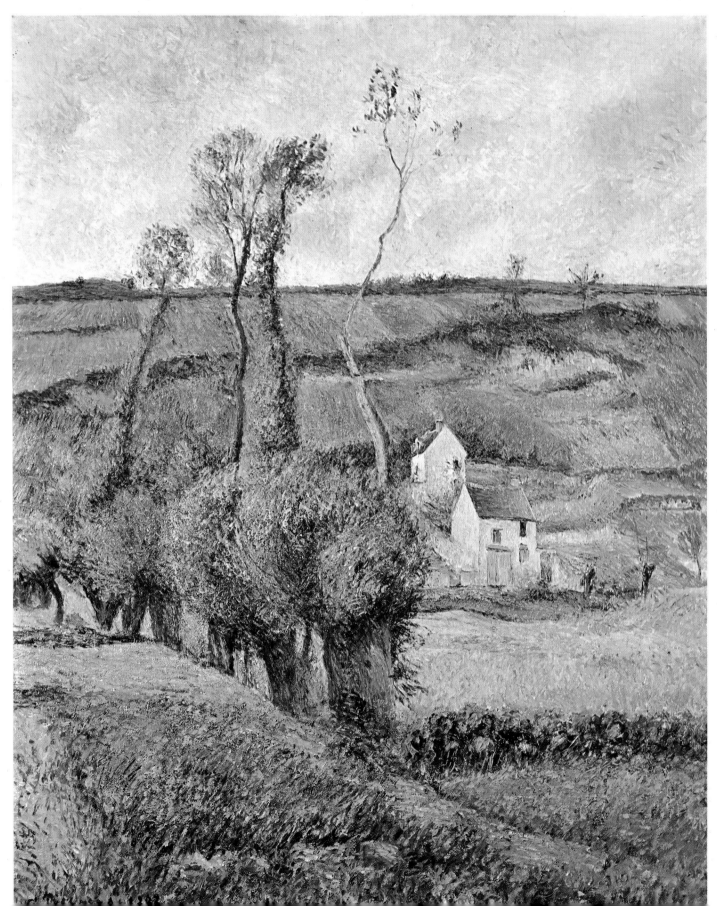

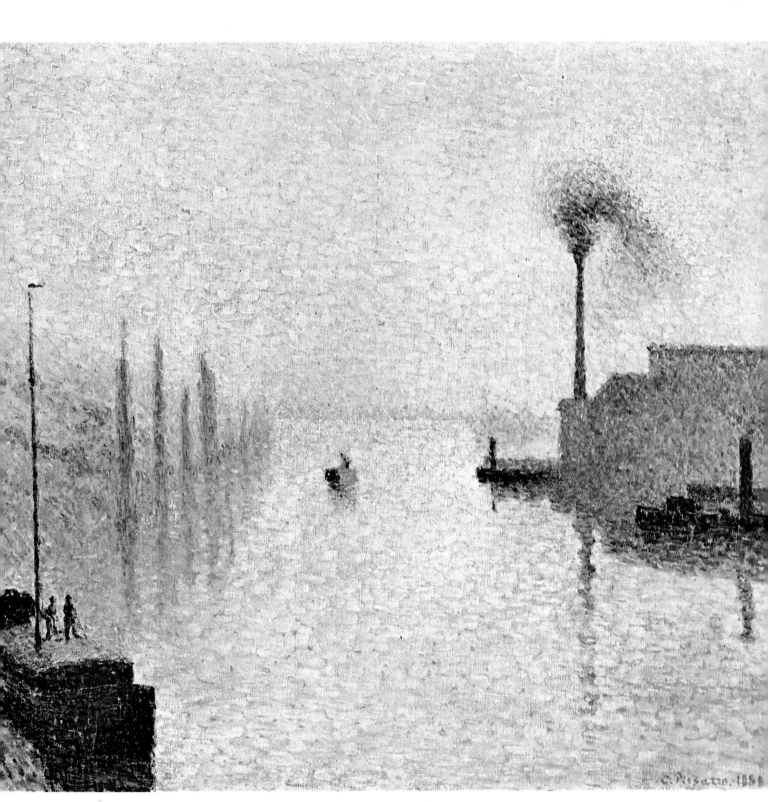

29. *Île Lacroix, Rouen, Effects of Fog* - 1888. John G. Johnson Collection, Philadelphia

30. *Unloading Wood in Rouen* - 1896. Private collection, USA

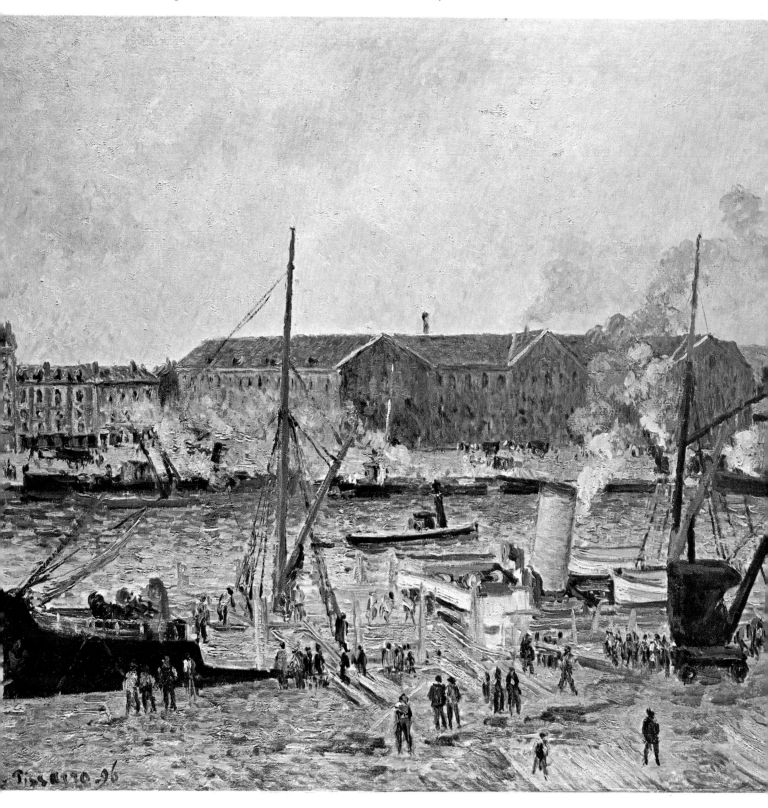

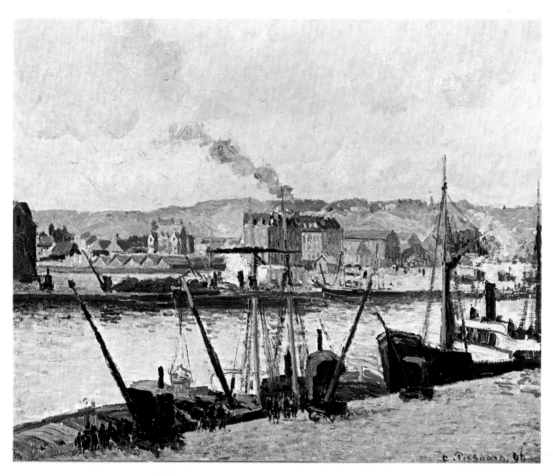

31. *Morning, Rouen* - 1896. Private collection, France

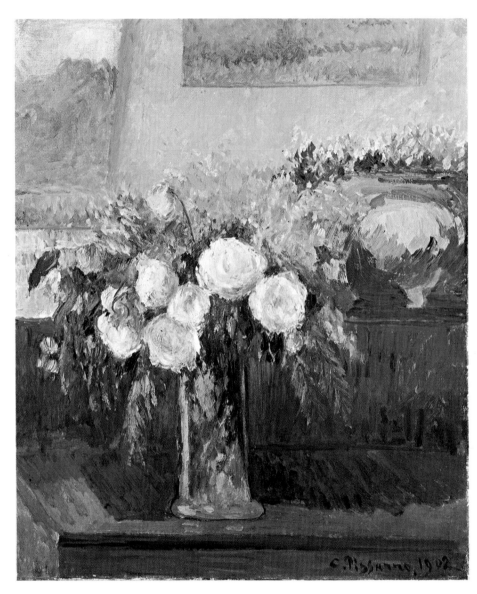

32. *Roses from Nice* - 1902. Private collection, USA

33. *The Vegetable Garden at Eragny* - 1897. Private collection, USA

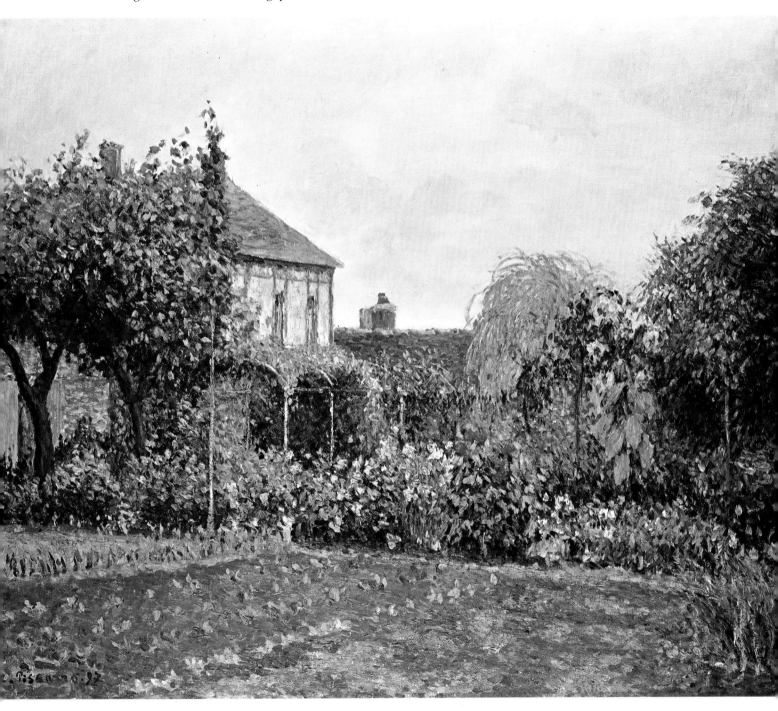

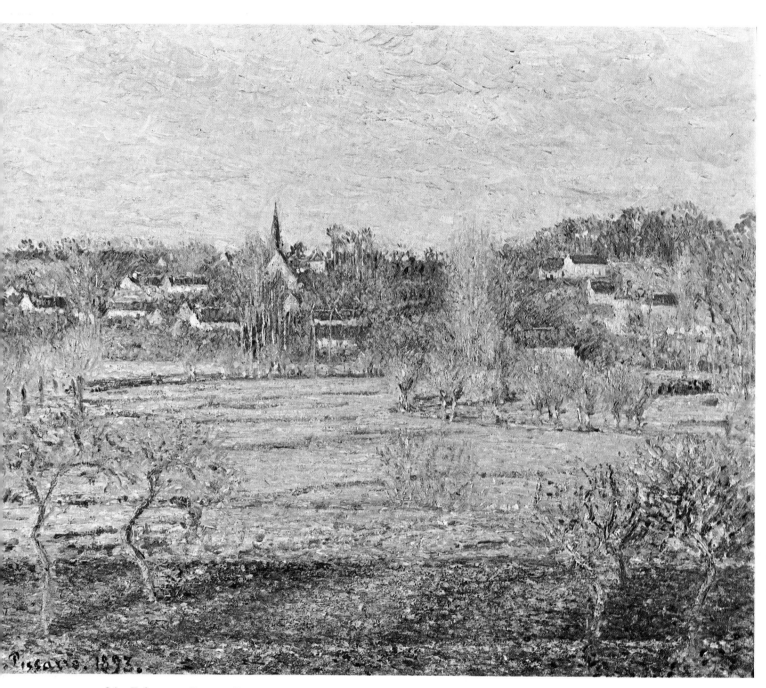

34. *February, Dawn, Bazincourt* - 1893. Rijksmuseum Kröller-Müller, Otterlo

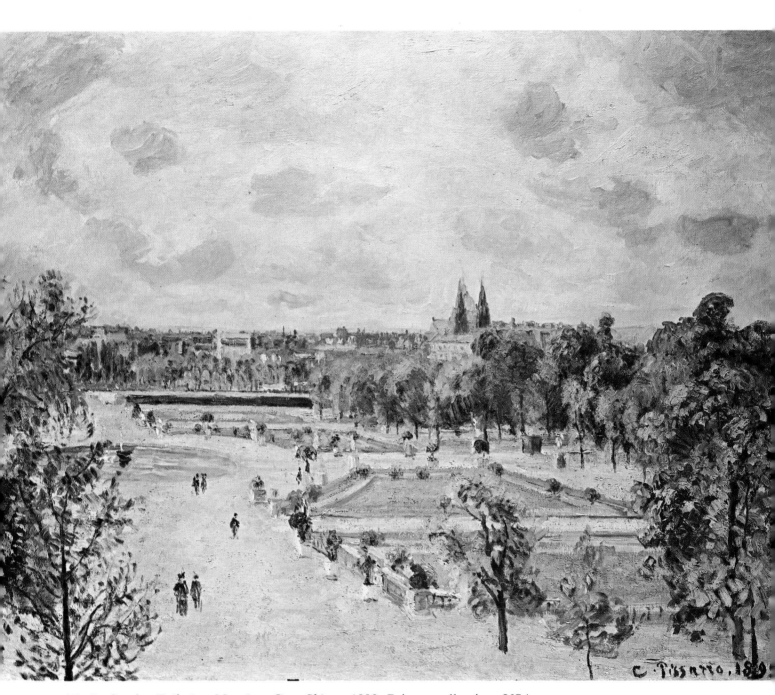

35. *Jardin des Tuileries, Morning, Grey Skies* - 1899. Private collection, USA

36. *Boulevard Montmartre, Night Effect* - 1897. National Gallery, London

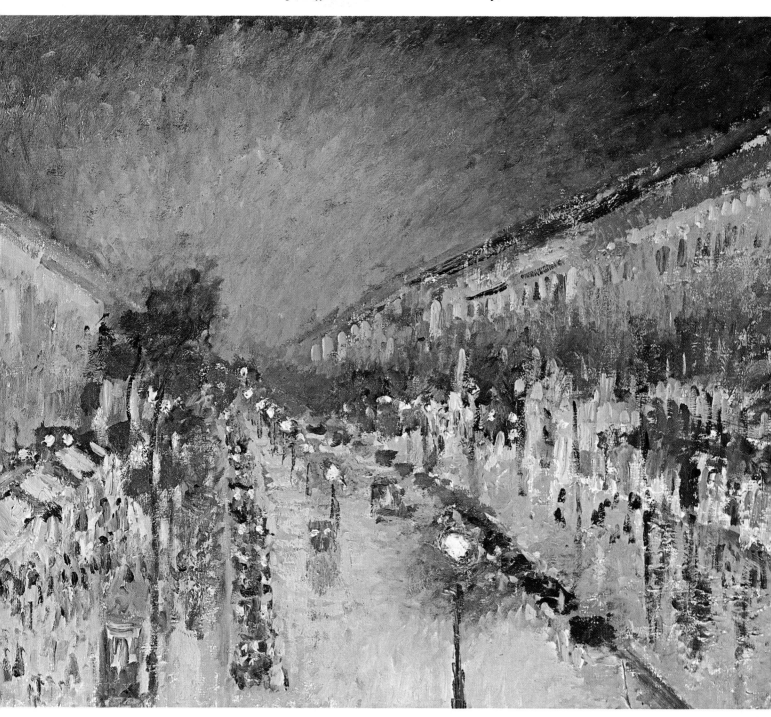

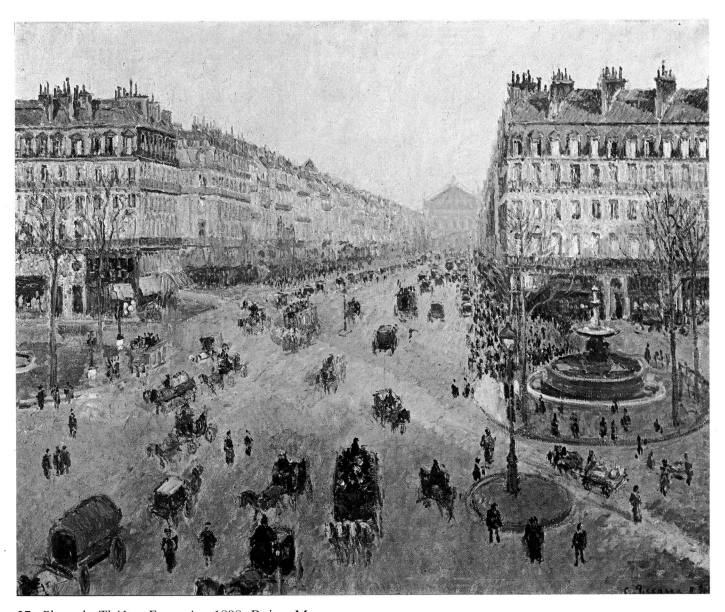

37. *Place du Théâtre Français* - 1898. Reims Museum

38. *Boulevard Montmartre, Afternoon, Rainy Day* - 1897.
Private collection, USA

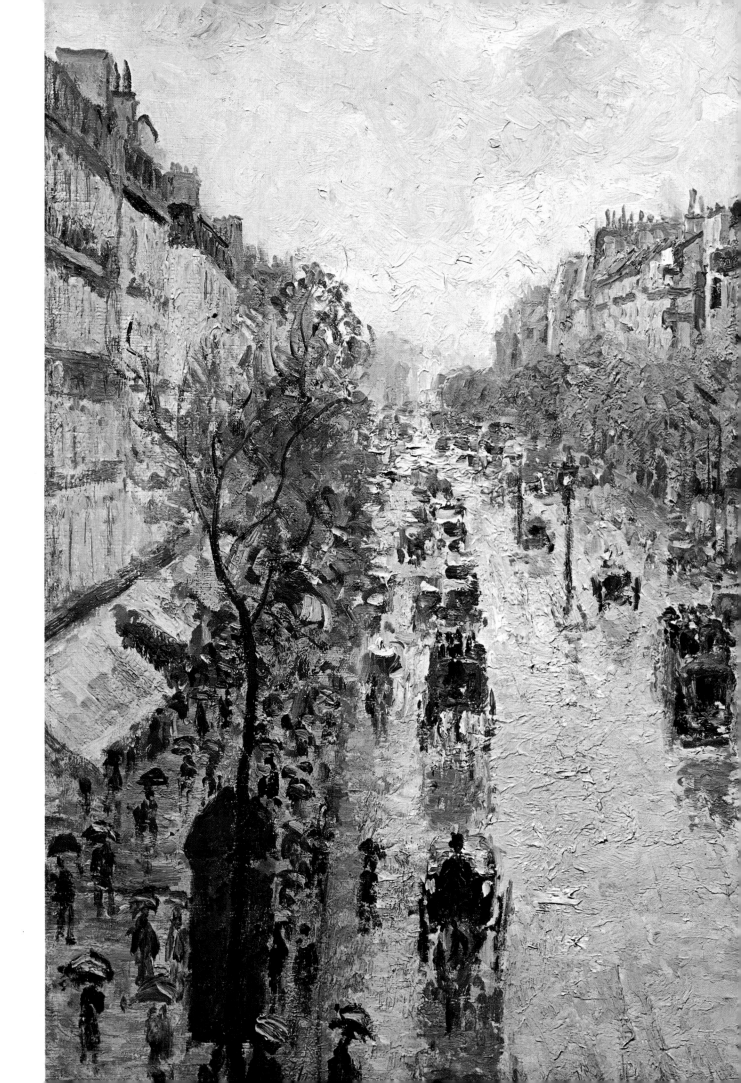

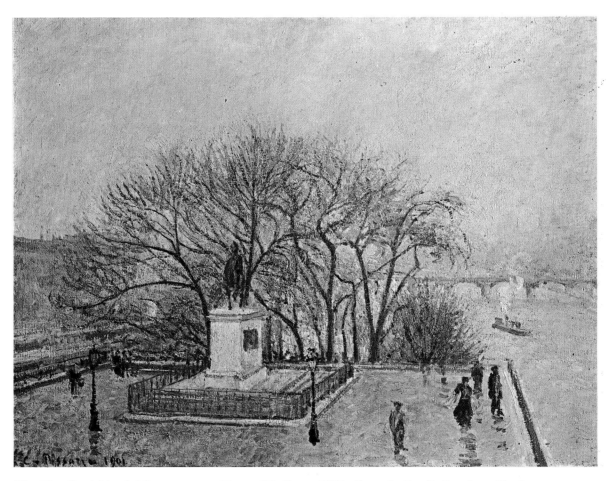

39. *The Pont Neuf, Monument to Henry IV, Fog* - 1901. Staechelin Collection, Basle

40. *View of the Seine from the Pont Neuf* - 1901. Staechelin Collection, Basle

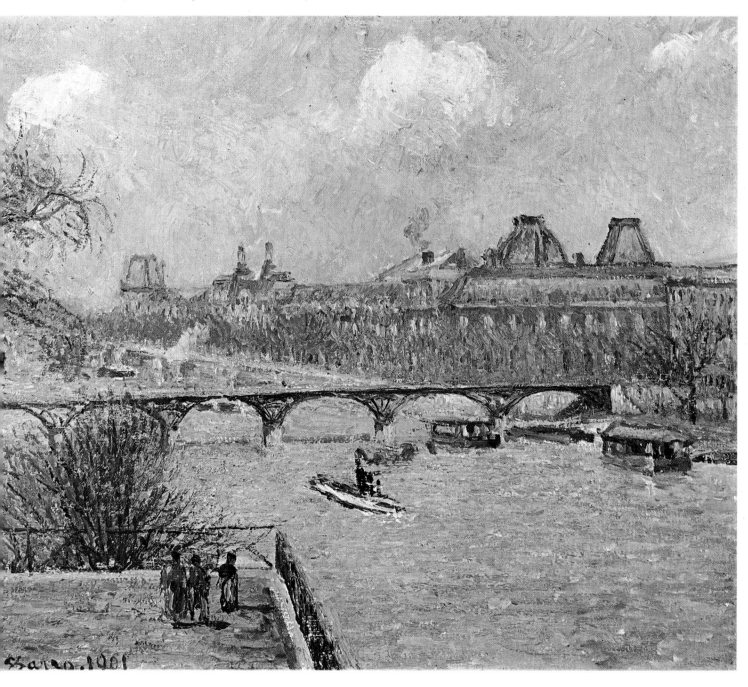

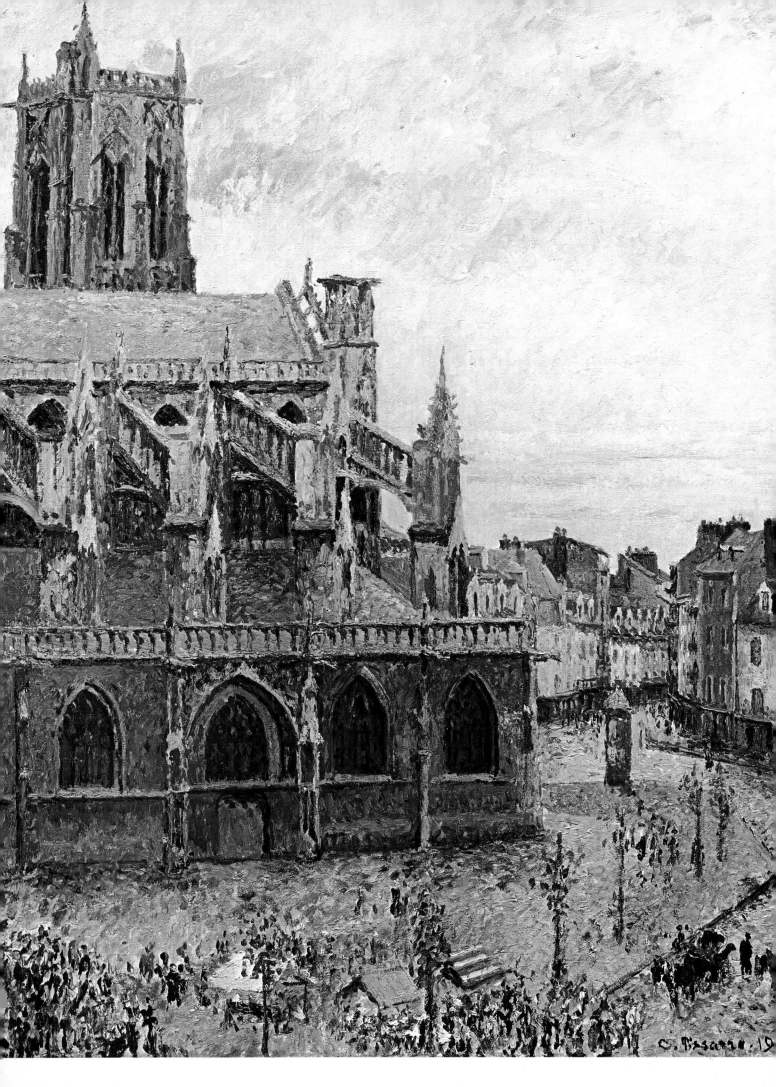

41. *Church of Saint-Jacques, Rainy Day* - 1901. Private collection, USA

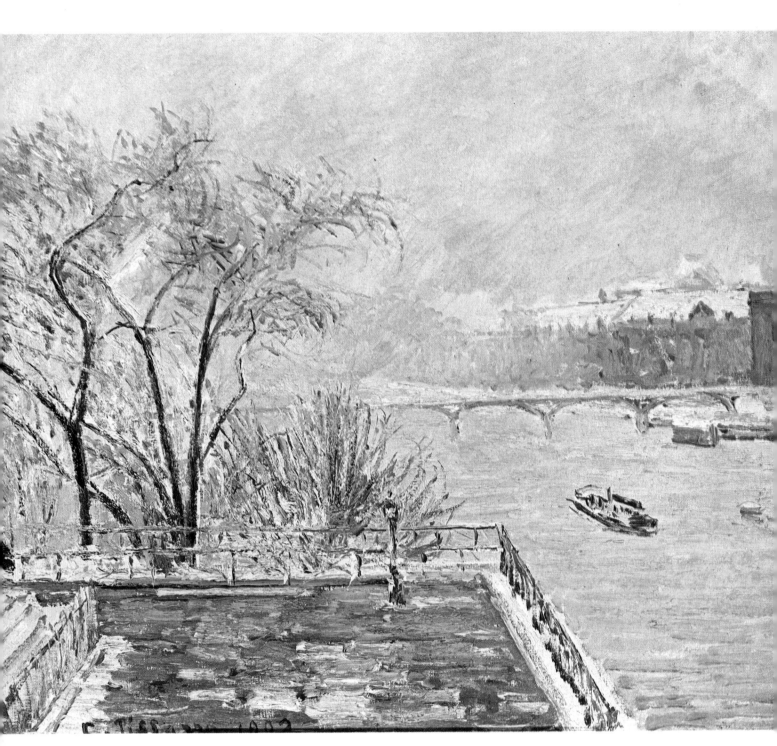

42. *The Louvre under Snow* - 1902. National Gallery, London

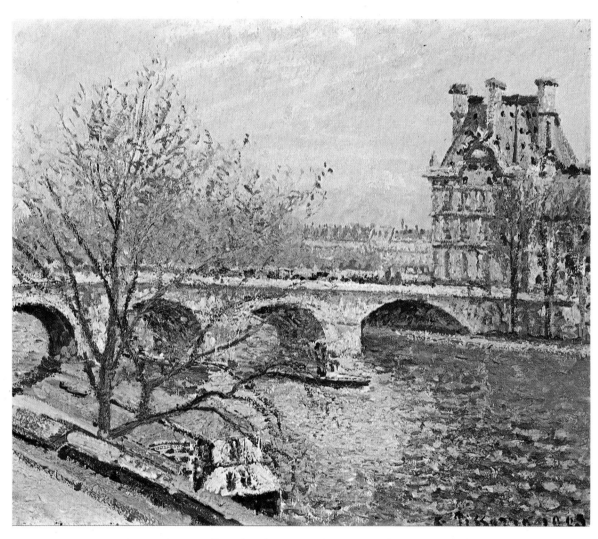

43. *The Pont Royal and the Pavillon de Flore* - 1903. Musée du Petit Palais, Paris

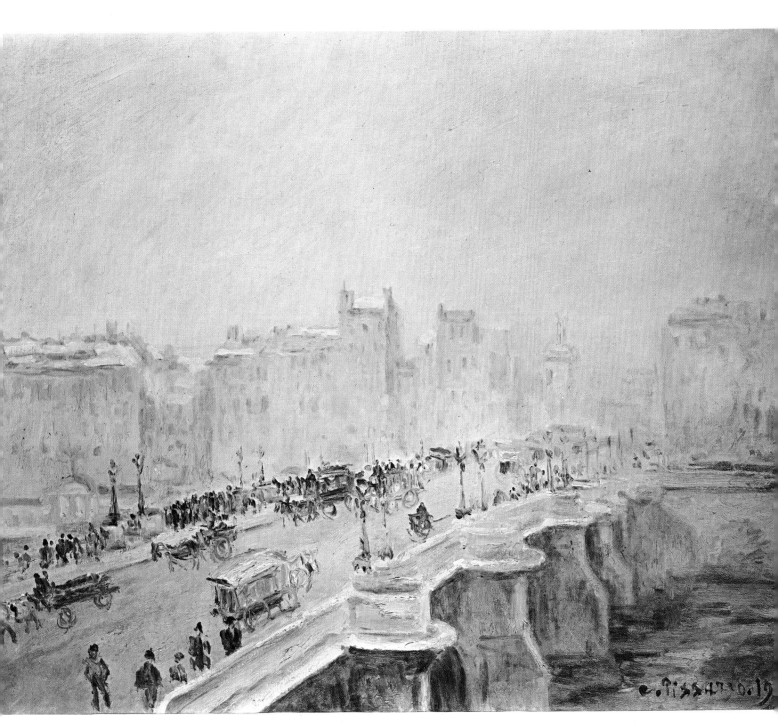

44. *The Pont Neuf* - 1902. Private collection, USA

Editor in chief Anna Maria Mascheroni

Art director Luciano Raimondi

Text Simonetta Rasponi

Translation Roberta Kedniewsky

Production Art, Bologna

Photo Credits Gruppo Editoriale Fabbri S.p.A., Milan

Copyright © 1988 by Gruppo Editoriale Fabbri S.p.A., Milan

Copyright © 1990 by **PHIDAL**
for the Canadian edition

ISBN 2-89393-051-4

Printed in Italy by Gruppo Editoriale Fabbri S.p.A., Milan

Bibliothèque publique de la Municipalité de la Nation
Succursale LIMOGES Branch
Nation Municipality Public Library

Bibliothèque publique de la Municipalité de la Nation
Succursale LIMOGES Branch
Nation Municipality Public Library